YOU ARE NOT TOO LATE

by Nikki McClure

ABRAMS
NEW YORK

Editor: Meredith Clark
Designer: Jenice Kim
Managing Editor: Mary O'Mara
Production Manager: Larry Pekarek

Library of Congress Control Number: 2021946835

ISBN: 978-1-4197-5838-6

Printed and bound in the United States
10 9 8 7 6 5 4 3 2 1

Abrams books are available at special discounts when purchased in
quantity for premiums and promotions as well as fundraising or
educational use. Special editions can also be created to specification.
For details, contact specialsales@abramsbooks.com or the address below.

Abrams® is a registered trademark of Harry N. Abrams, Inc.

ABRAMS The Art of Books
195 Broadway, New York, NY 10007
abramsbooks.com

For Finn

I make time. Since 1998 I have made a calendar every year to accompany us as we spin around the sun. *You Are Not Too Late* is a collection of my calendar artwork from 2015 through 2021. The artwork from 1998 to 2014 is gathered in my previous book, *Collect Raindrops*.

Each week I sit down to a black square of paper and cut out the future. The images I create hold many stories from the past, the present, and the future. There are stories of lived memories, as most of my images are inspired by events in my life. There are also stories of the work of making and the meditation of that time—cutting and cutting and then a word pops into my head, and I add it to the sketch, the list growing, and then back to cutting and cutting, the present weaving with the past. There are stories of when the image appeared on walls throughout the world as the art for that month and year. In that collective moment, magic resonance happened, and the art synchronized with the present. People had conversations and wonderings. The art and word for that time became a mantra, an exhortation, a reminder. New stories were made. And then there are the stories of the future— the moment when this book will be opened to a random page and the image will enter into a life that is always changing. These are only a few of the stories that I have to share. There will be more. The spinning will continue. I will keep making time.

In 2015, my son, Finn, was eight, then nine. I moved here, to a beach tucked away from the storm winds and next to the sea. Here was different than the perch I had occupied on a hill of glacially ground sand paved over with a grid of light-ribboned streets. The way I lived my life shifted in this new place. My work changed, and my stories and sense of time deepened. Here, there are deep piles of clam and oyster shells, middens made by the first inhabitants of this shore. The white shells were covered by sawdust from the oldest trees cut with the first sawmills. The beach-buried layers of dust and shell open up again with winter storm waves and rain gullies. Here is a cedar with stout limbs bent upward like a semaphoring octopus and with a magic circle at her base. Here is tides. Here is the time of moon at night and time of owls calling.

Time is measured differently here. Time is marked not only by lines penciled on the doorway marching ever higher, or calendar days filled with appointments, but also by soil creation and composition. Clay yields to vole, hole by hole, leaf pile by leaf pile gathered from autumn raking. Slowly. Thousands of years of leaves will make enough soil for a carrot to grow comfortable. Cedars are better suited for this time work. I am too idle; I have worked too much. I need more blackberry time—with too many to fit into my hand and with no bucket other than my belly. I try to stretch out summer by leaving the sticky purple stain on my fingers well into winter. I can smell that warm sweetness now as the buds begin to re-leaf this world. My fingernails are dark, my tongue blue, my arms are scratched and they sting when I swim. I taste the smoke of that night. Here is life in the open and in whispered shade. Waken this part of you. You are not too late.

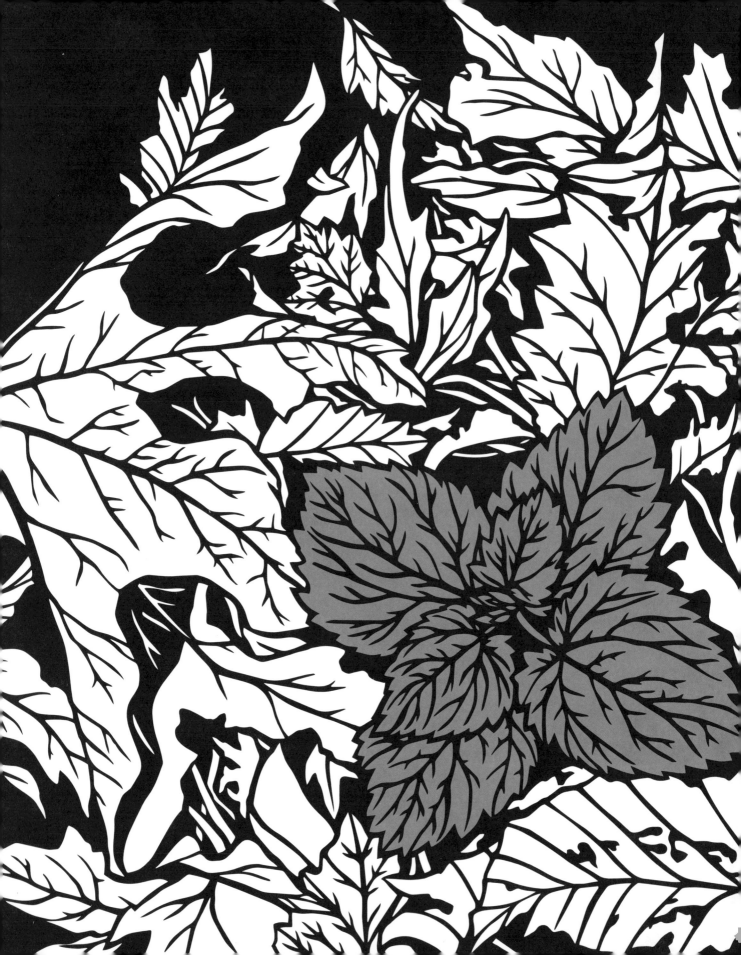

DARE

The first leaves of nettles appear as unexpected friends that you meet on a walk and whom you want to take home for dinner, but you've got no gloves. Old maple leaves do until they don't. By morning, the feeling is gone, and you will forget your gloves again.

The first nettle hunt always starts before there are nettles. I wander off into the forest in the winter. The ground cover is low and easy to move through. There are no wasp nests to step on. Deer paths are more nuanced than efficient. I have read that fifteen minutes of walking in a forest strengthens one's memory and remember that much before pausing on the verb: *strengthens*. *Encourages? Dares?* The tangled path. The complicated journey full of challenges and obstacles dares me to remember. Next time I'll bring gloves.

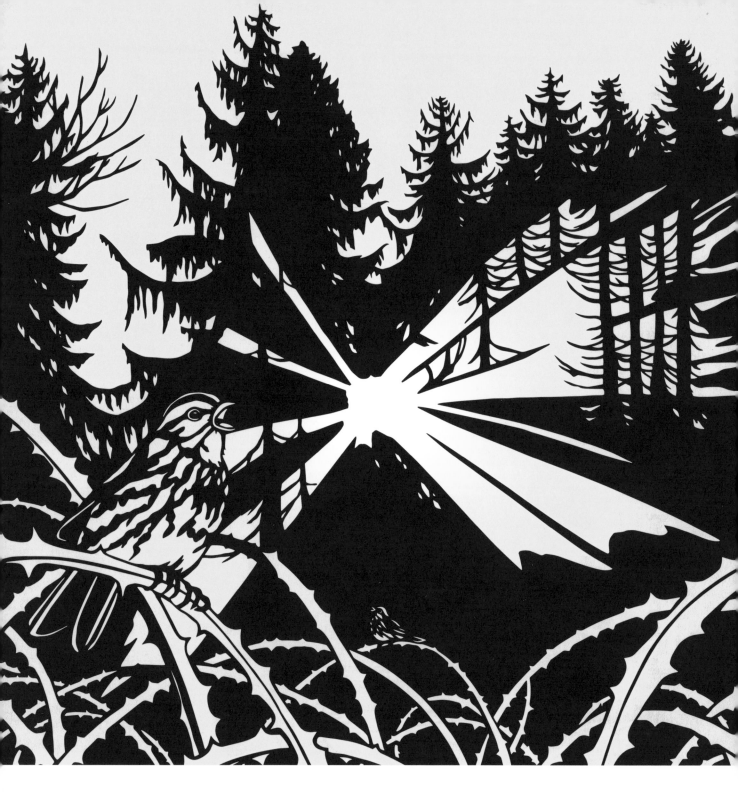

THRILL

The tangle of summer is on hold. Light breaks low and to the south. It cuts through the warm earth breath of the forest. A song sparrow sings not for me but for this day beginning. There is a thrill in being part of something not meant for me—this dawn in this forest with this song.

BECOME

How many kids can you fit in a small sailboat? How many should you? How do you become a pirate if you never try?

RECTIFY

The birds have parties on sunny winter days. Lives that are lived too quickly for reflection are tricked by the bright light shining off the windows. Every year there is a bird to bury. We stop our work and tend to the task. We find a tree and dig a hole at its base. We line the hole with ferns, and we speak kind words. There is a moment of silence. And then life resumes with the possibility that the tree will

TRANSFORM

When pussy willows become tiger tails, women march with power.

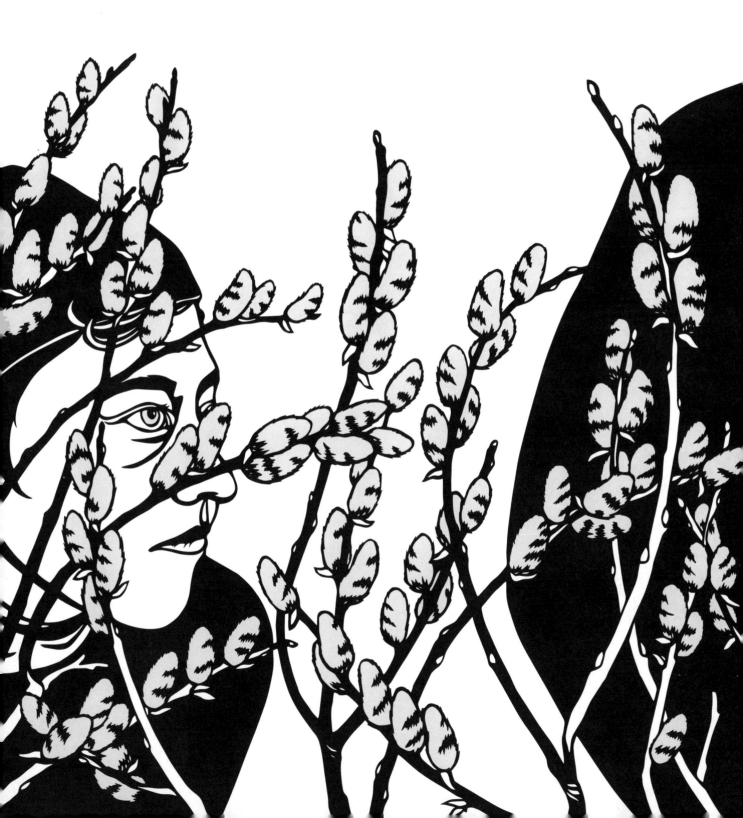

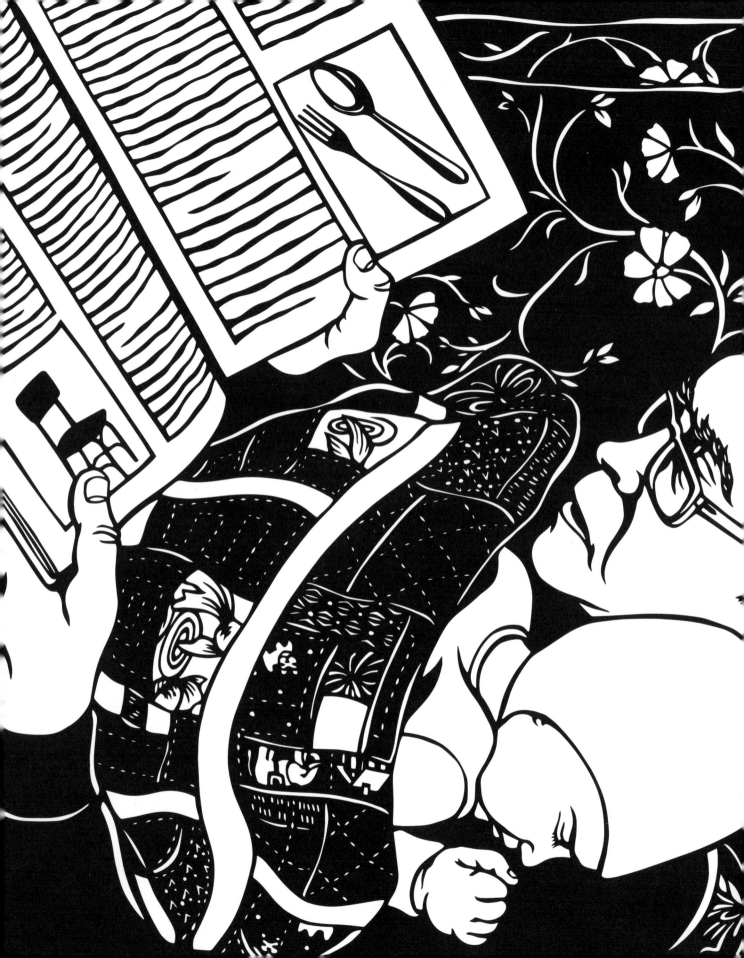

INSTILL

Winter brings books. Piles of books grow on every horizontal surface, and the couch is never long enough. How do kids learn? When does learning take place? Does it happen when heart beats are synchronized? Over stories heard in beats and breaths? Jay T. read a book on Swedish design while Finn "listened." The couch was pink satin. I got it when I turned thirty. I was ready for a couch then. It was in my studio for a while until I was able to buy a house. It was a magnet for long conversations and naps and learning.

What did I consider as I contemplated this image? I knew we would inaugurate a president and would have an election disputed forcibly if the results were not transparent and overwhelmingly obvious. I knew that the world would be deep into its second winter of the COVID-19 pandemic and that there would be deep grief and loss as well as immediate suffering as people struggled to be safe and housed and fed and emotionally cared for. I knew that the way through this would require being optimistic and realistic, and it would take bravery to be both. And I knew that it would rain. What I did not know was that my mother would die on January 4th from COVID-19.

I was scared to make this picture. I felt like I was touching pain and tragedy too closely. It was a vision that I could feel the strength of and that I had to be brave and confront, knowing I had opened myself to the consequences of its creation. But I knew I would have the courage to face it all with eyes wide open.

FORWARD
WITH EYES
UNBLINKING

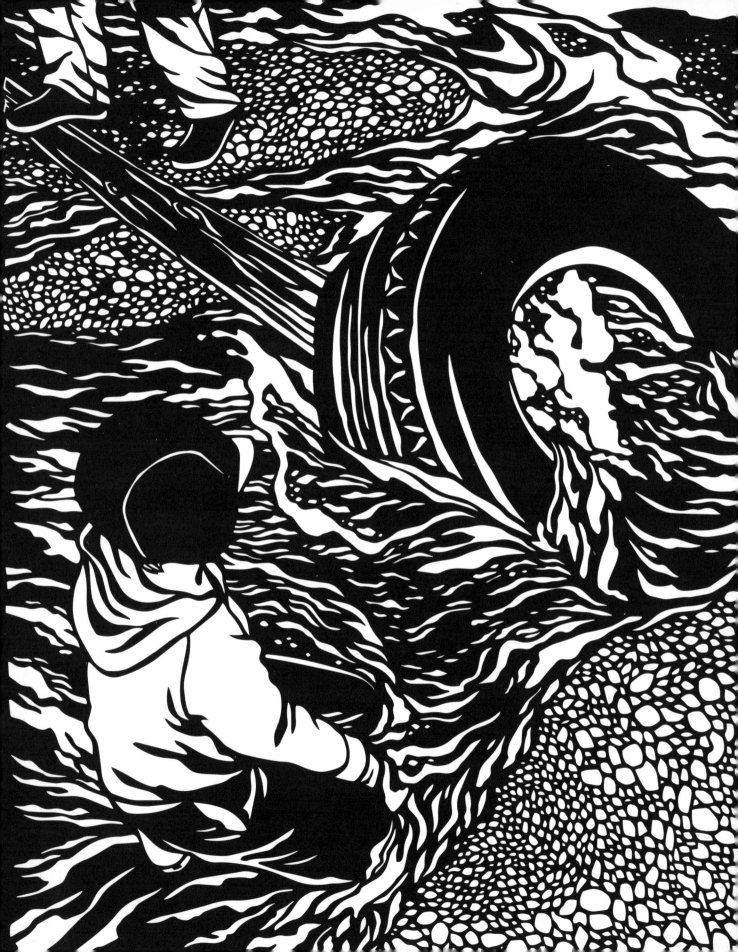

LOVE

It was February and raining. I was being inter-
viewed. I needed a break and fresh air. The tide
was low so we went walking; the interviewer kept
her tape running, microphone held out to me.
The rain was streaming down, cutting through
the pebbled beach, deep enough to uncover the
tire. We would only see the tire once a year during
a heavy rain and low tide. When the water rose
again, the tire would be covered up until next
year. So we went for it, with the microphone on
and the stream of water rushing. Using a pole to
lever and bark to shovel the infilling pebbles, we
got that tire out from its grave. It is on record,
this act of love.

TRANSVERSE

February is the time when I can rouse the coziest for a night walk. "Let's go on an owl hunt." People who never walk in the forest by day can be convinced by mysteries remembered in cells and molecules, even if they have never openly contemplated it. We use lights at first, and then one by one they turn off. Light is no longer needed. The sky is not as dark as it once was. Clouds glow from cities and illuminate the woods far away.

In the not so dark, everything changes. Objects grow larger. Wet branches curve to the moon. We hunt and always find something. Sometimes it is an owl.

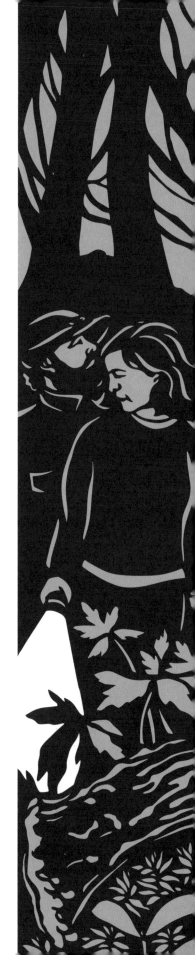

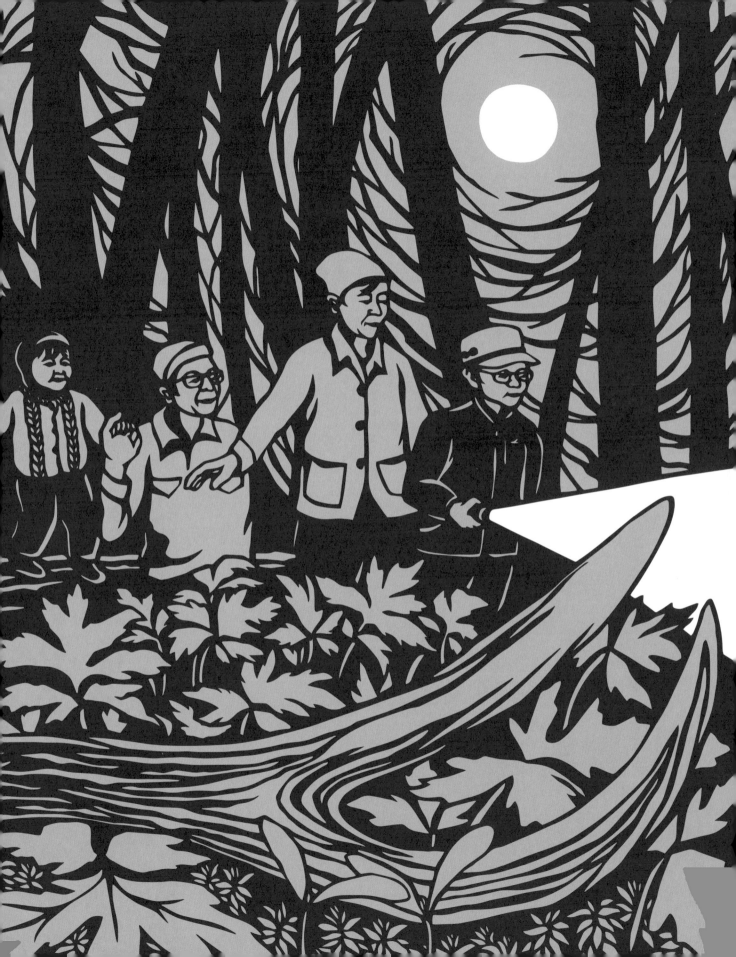

EXPAND

There is a golden-crowned kinglet, osoberry, and me. I don't know how we are linked. I yearn for the green. It makes my eyes wake. The fairy tinkle of the kinglet calls me forward. And I expand.

I drag the canoe out for a quick salvage or rescue or impromptu adventure, and I know that I have forgotten to fix the seat, again. The slope of the beach makes it easy to pull the heavy canoe down. The loud scrape of rocks gives way to light, quiet ease once the canoe slips into the water. The seat is accommodated easily too. It is not needed for adventures this quick and urgent: a log drifting by to paddle home, my mother trapped by high tide, explorers headed around the corner into the uncharted world. I straddle the seat as best as I can and determinedly paddle out.

RENEW

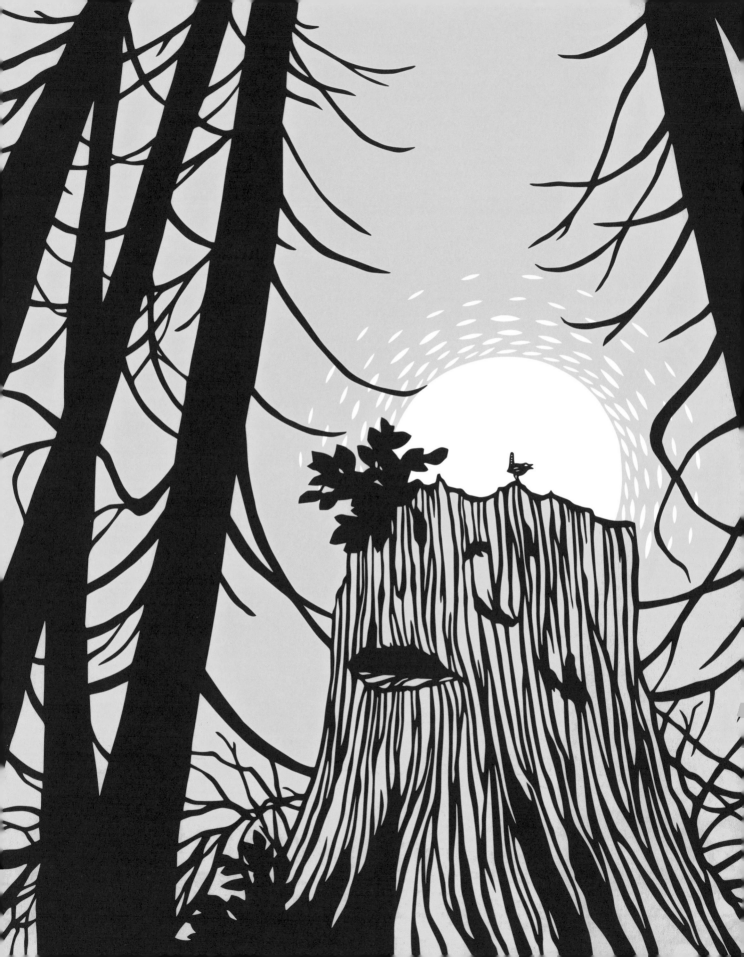

ATTEND

The oldest tree stumps have notches cut into
them. Loggers would place boards in the notches
to stand on. The trees were so massive that their
roots and buttressed trunks stretched into the
forest. By standing on boards, men could cut the
tree higher up on the trunk, but still have to work
all day sawing. This story is disappearing into the
soil. Now we celebrate big trees who survived this
slaughter, as they were too little to bother with
or even be seen. And the littlest wren sings bold
from its perch, a song heard when the woods are
open, before the green enfolds.

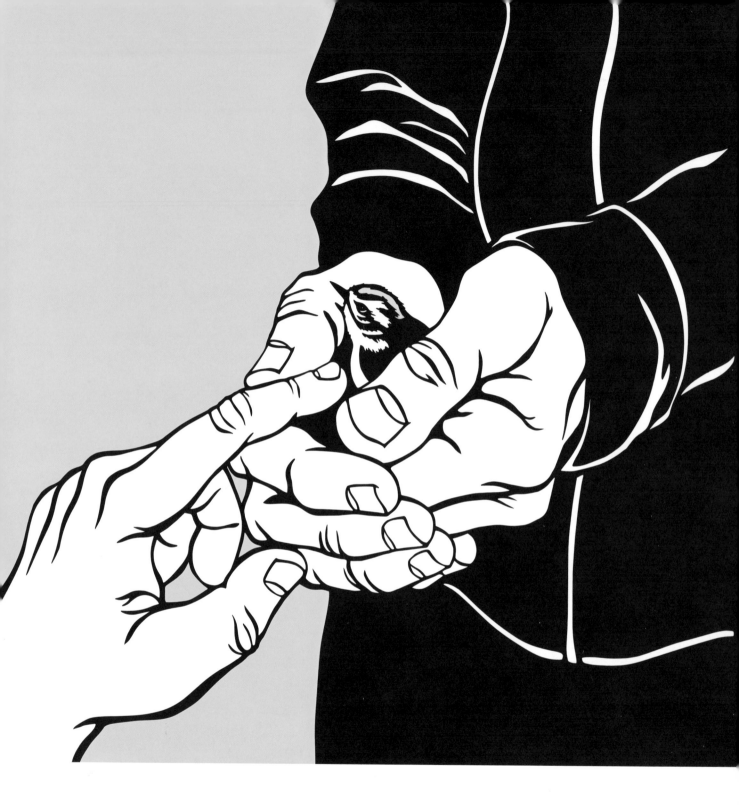

SPARK

The kinglet is temporarily stunned. How can it feel like I am holding nothing? Held, it relaxes and stirs to motion and disappears. From there to not there. We were so close that once.

FEBRUARY 2020

In January I start visiting the part of the woods where the snowdrops grow. They are remnants of the old bulb farm. They are slowly escaping, bulb by bulb, into the wilderness. The first green tips excite me, and I try not to step on even one. I do not bring anyone here. Extra feet of the unknowing would trod on the flowers just as they poked up. I always start looking too early. I note when the first one blooms each year. The fanciest ones, multi-petaled with green ruffles, open first and delight in their show-off ways. Next to open are the tall and elegantly simple snowdrops. The ruffled ones shrivel in their unnecessary glamour when true beauty opens. I pick a handful for my neighbor who remembers the flower farm, but no longer ventures into the woods. There is triumph this year in surviving the winter, so I made a bouquet to give to everyone.

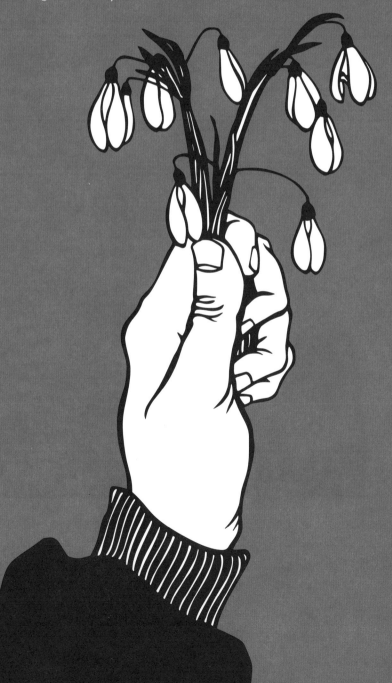

EMERGE

We walk this avenue of osoberry and waterleaf at
equinox, promenading with matched stride.
This is the way our hands lock into place and we
step forward each spring—balanced, equal.

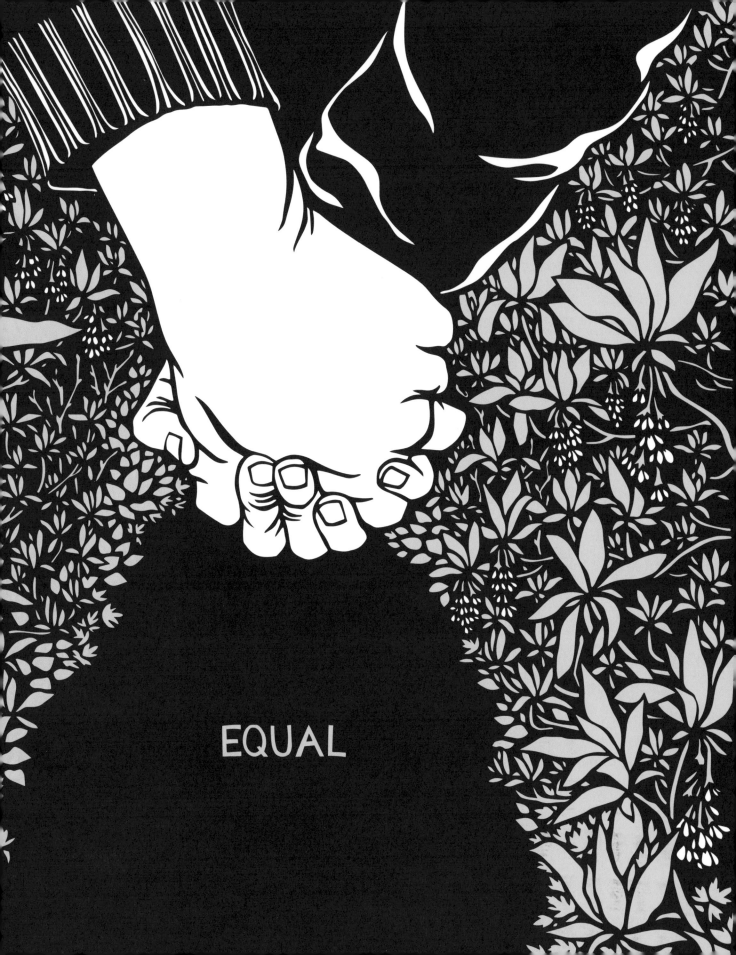

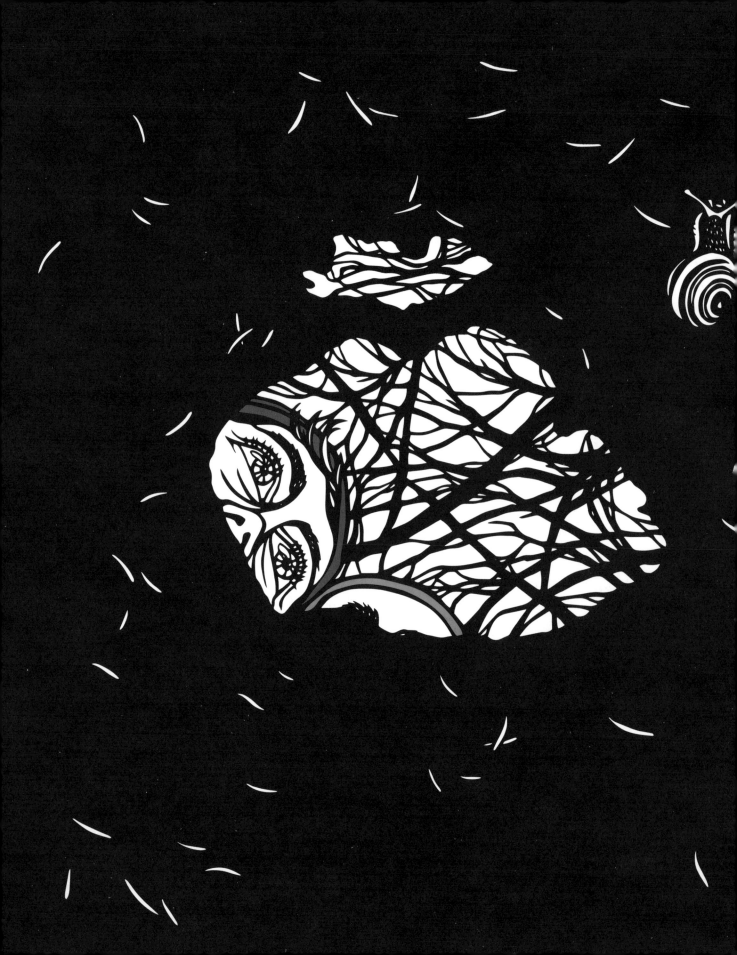

QUESTION

I take the long way to work in the morning. I head out my front door and walk along a road until I hear cars, then I turn and walk into the woods until I come to the beach. I walk and see what the tide brought in and what the wind is like and if there is snow on the mountains. Then I walk up a small hill to my front door, open it, take off my shoes, and put on slippers. I pour some tea and walk downstairs to my studio.

Sometimes I don't turn into the woods. Instead, I walk along the road just to see people zipping by and for me to be seen by them. We create community at forty miles per hour. I am The Walker. They are The Drivers. I feel fortunate that I am able to walk to work and return to my own home. But one morning I see two snails on their commute, navigating puddles on the sidewalk, and motion and work and community and luck are questioned and altered.

BALANCE

The plum tree blooms in March. Petals start fall-
ing, dotting the ground, and then this moment
of beauty is over. So I stop. I lie down. My clothes
get wet. I exist in the perfect balance of life and
work and motherhood and self. Mothers are always
asked how they balance life and work. Maybe it is
not fair to ask mostly women this. But maybe they
are asked because mothers know the answer.

Drop down under a plum tree until petals cover
you, even if the ground is wet, even if there is
dinner to be made, even if there is a deadline.
You will be damp, dinner will happen, just later,
and the deadline will be efficiently met, and you—
you—will long for that moment next spring when
the air smells like flowers and you fall down.

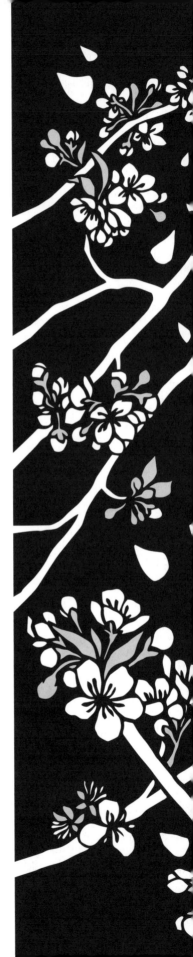

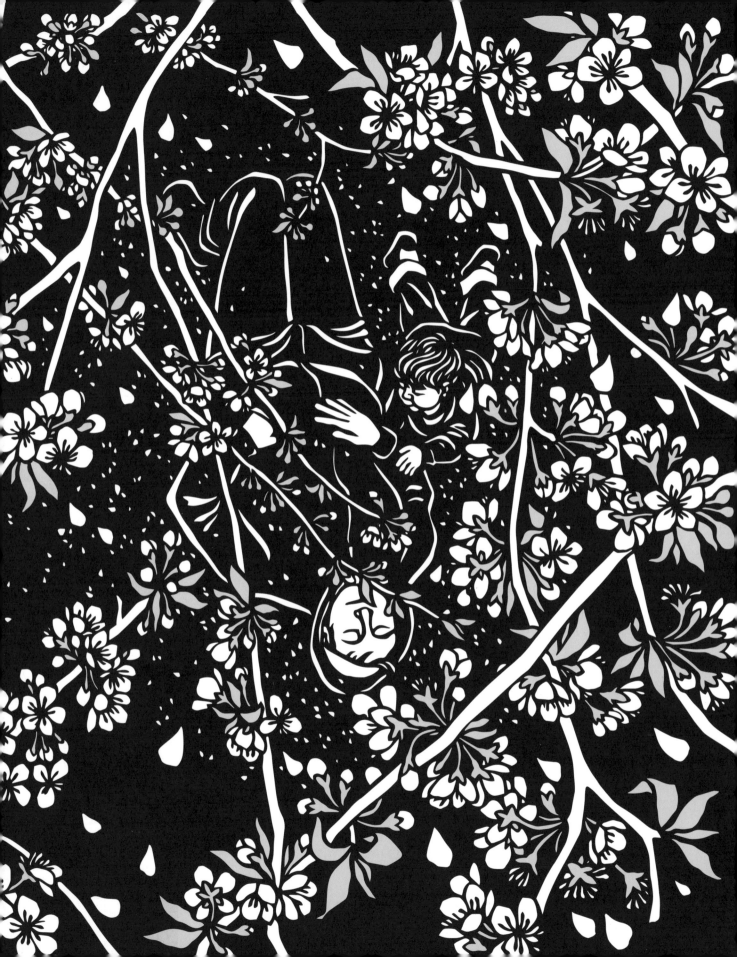

ASTOUND

It was the first day of spring, and my friend Lea wandered from the forest trail onto the beach. The air was warm and the rain steady, direct from Hawaii. Lea walked into the water, wearing pants and tank top, and dove in. I didn't join her. I wished I had. I had work. I had something important to do. But when I went back to my desk, I did not work. I did what was important: I made a picture of Lea and that first day of spring and how she honored the storm.

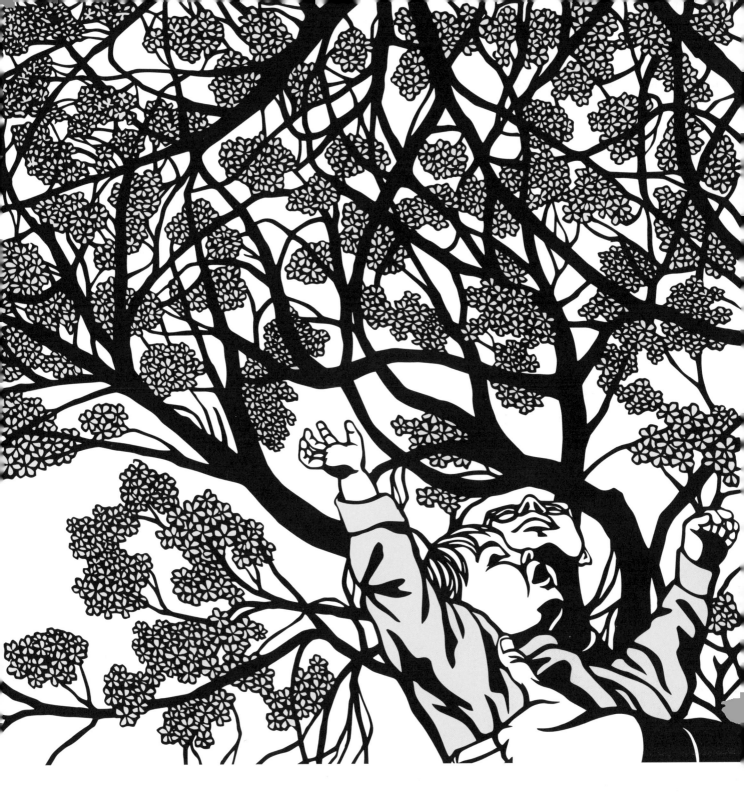

AGAIN

Here we are again, waking up. Spring is the morning if a year was a day. Again and again and again, we spin under the cherry trees. We are summoned for a spontaneous picnic of sushi and lemon cake again and again and again.

MARCH 2019

Finn and Little Goldie Hen hatched the same day. In the changing home life, the new little chicks were not noticed until the other hens had killed two of them and had pecked Little Goldie Hen. She had no feathers and was bleeding when Jay T. brought her in and nursed her wounds. He placed her in a box on the dining table, then went back to tending to Finn and me. Eventually we all recovered, and during her first winter the chick lived in a box in the garage with a little mouse as a friend. Little Goldie Hen was Finn's companion as he dug in the dirt; they grew up together. She would even let him touch her eye. They were both mesmerized by the connection.

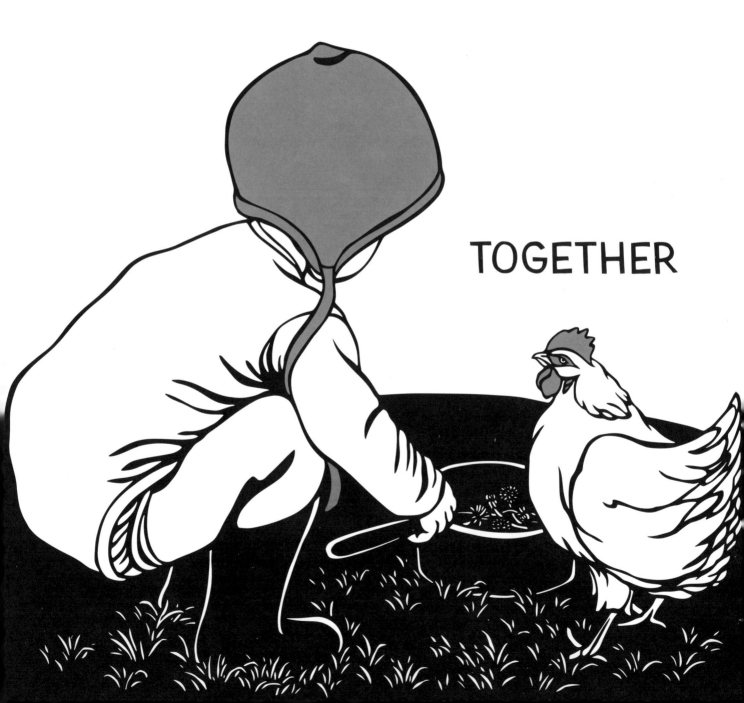

TOGETHER

ADAPT

One year after the pandemic began, we have adapted to eating outside. The year before, I remember seeing two forks touching one another after a meal. We had just finished an outdoor picnic for our small family. In the past we would have had a party of fifteen people, but now there were only the three of us. And even then, that our forks touched seemed an invitation to transmission. It was intimate. It was an act of trust.

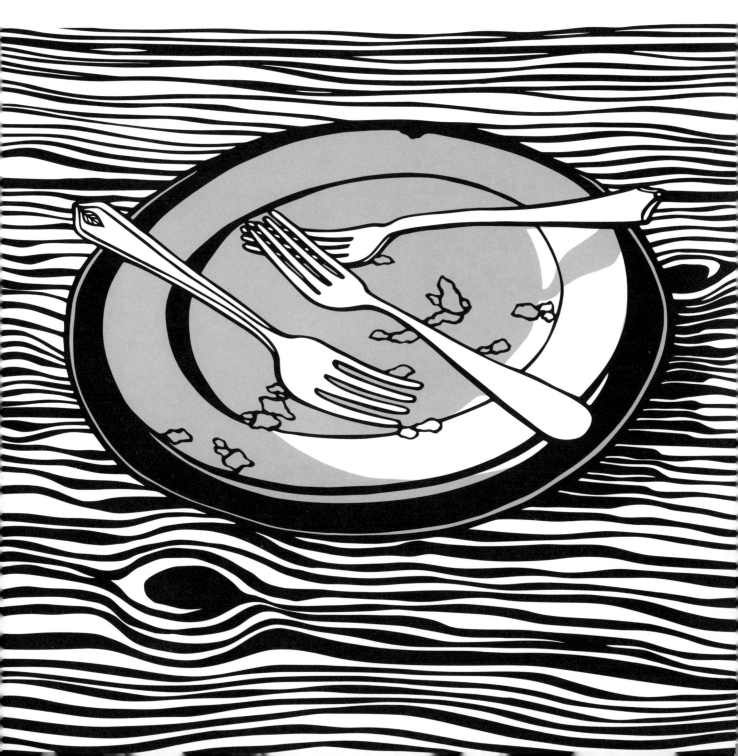

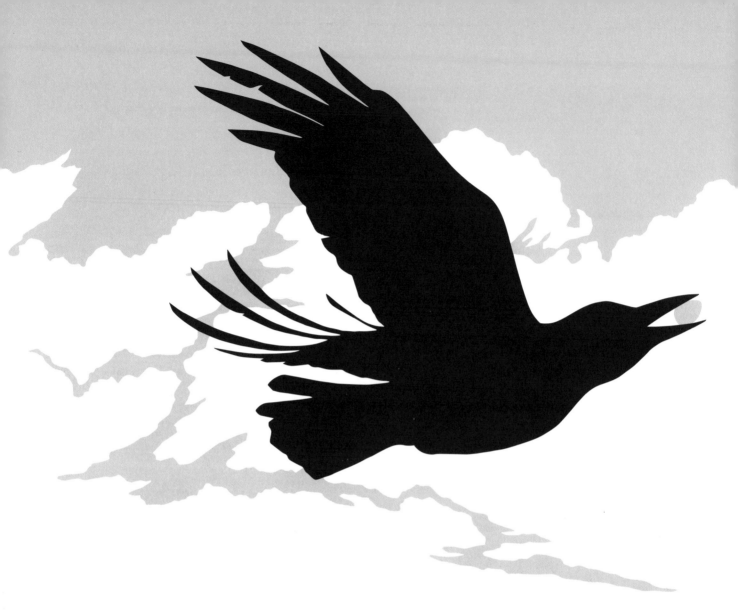

GIFT

What is that crow doing with a piece of blue gum? It disappears into the treetops, and after, as many wing flaps, I finally see the robin's egg in the bird's mouth once the crow is gone over the forest, into the morning sky.

We play a game of hide-and-seek where both players are seekers and hiders. I mostly am a hider. I find the darkest corner under a cedar and wait—with rising fear and heart pressure—while Finn hunts for me. With all senses alert, I strain to hear or see through a tiny opening in the swaying branches, summoning all my intuition. I try to find a place as hidden as where the mallard nests. Every year, she lays her eggs somewhere nearby, but she is secretive, and I am too polite to follow her when she flies to the edge of the forest. A twig snaps. Finn advances closer and closer until I can't bear it anymore, and I stand up and surrender in exhilarated glee. I promise to be a better hunter next time.

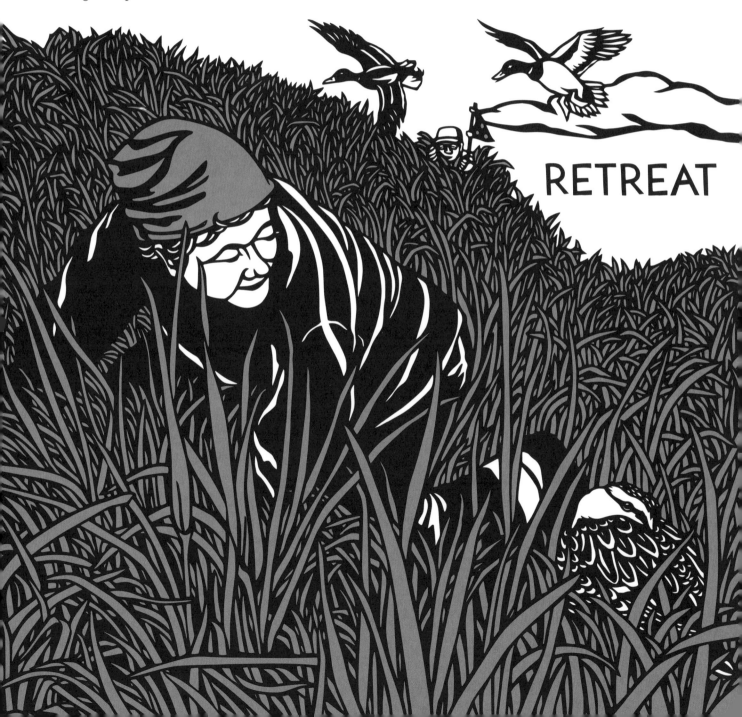

RALLY

The petals are falling! I keep drawing pictures of my arm splayed out on the earth, but they keep looking like I am dead. There is no time to explain though—the petals are falling! Quick! Follow me!

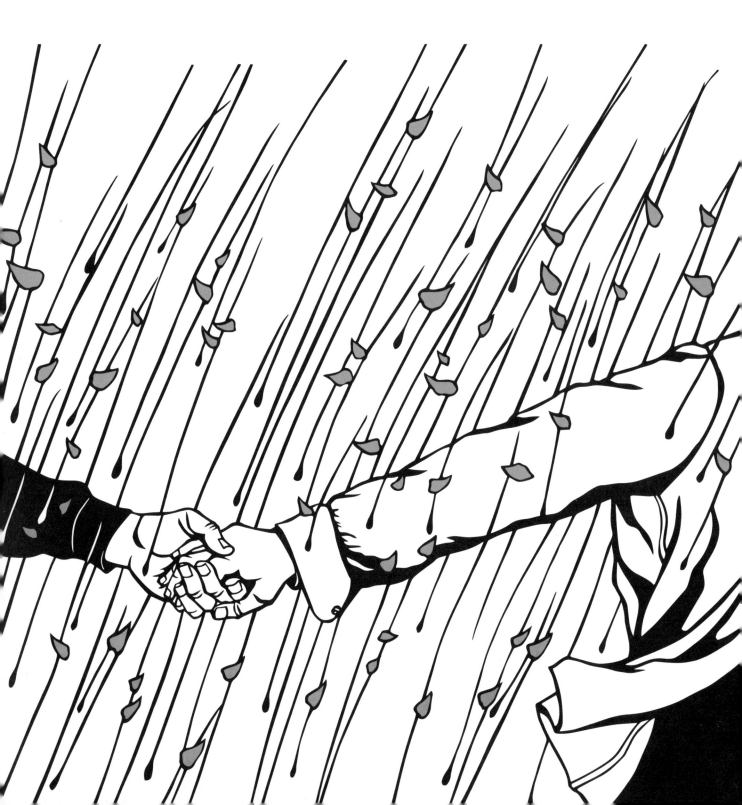

YOU ARE NOT TOO LATE

The potatoes have sprouted, reminding me that they are living beings and should not have been left in the back corner of the cupboard. They have ambitions. And though it is no longer Saint Patrick's Day, it does not matter to the potatoes. They know it is spring in that dark cupboard. And they know that I know. I take the potatoes out into the light and grab the shovel. I am not too late.

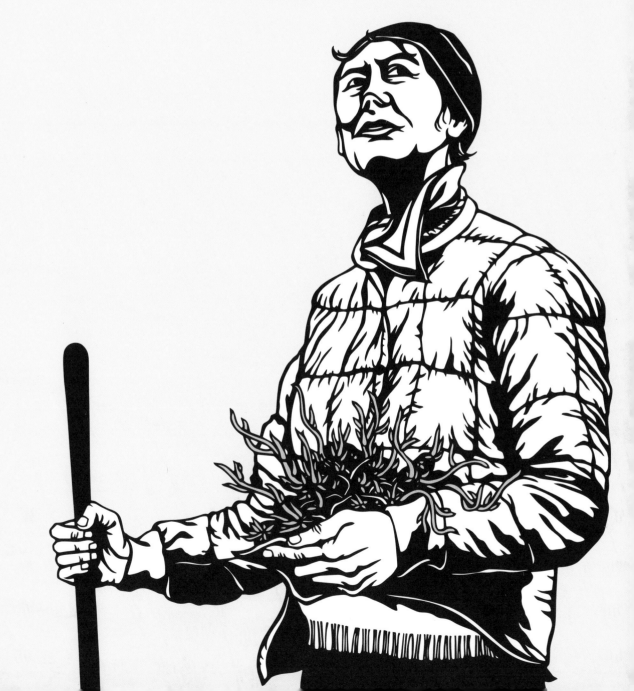

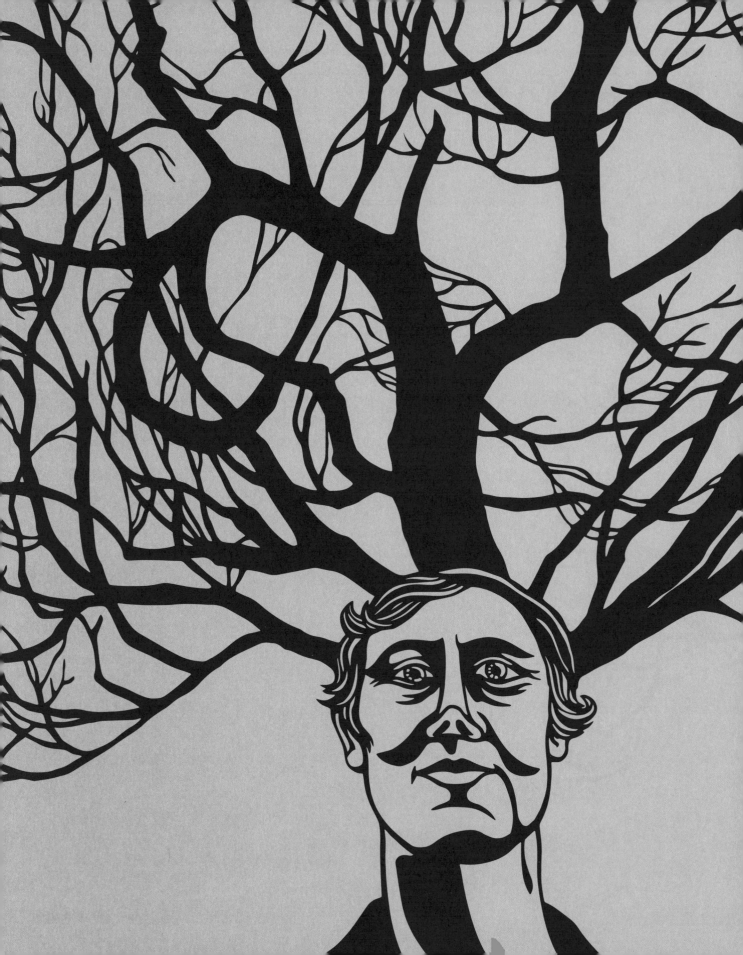

OPEN

Sometimes, I am a tree, and my thoughts are limbs expanding to make use of the light. We had hoped the pandemic would be under control after a month. But it wasn't. Human-centered systems closed and a connection to the world opened. Trees and birds became our neighbors, and we presented ourselves as openly as possible, making use of the light of spring to grow stronger.

INNOVATE

There is a crack in the sky where we can see space.
Crows gather branches and finish their nests, and
we look to the blue and hope too.

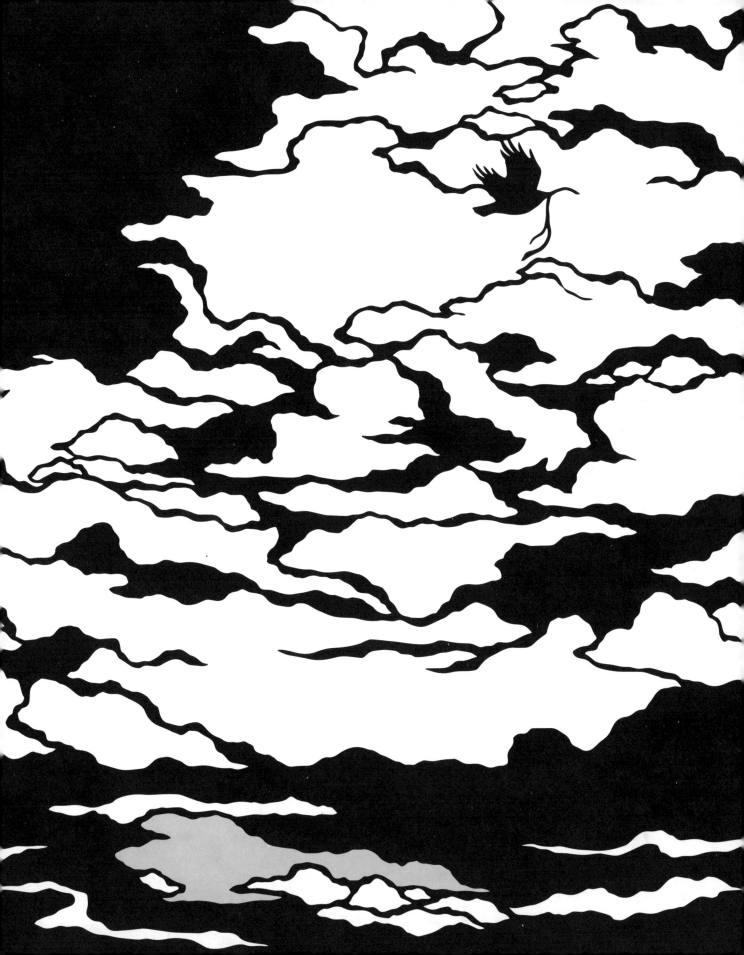

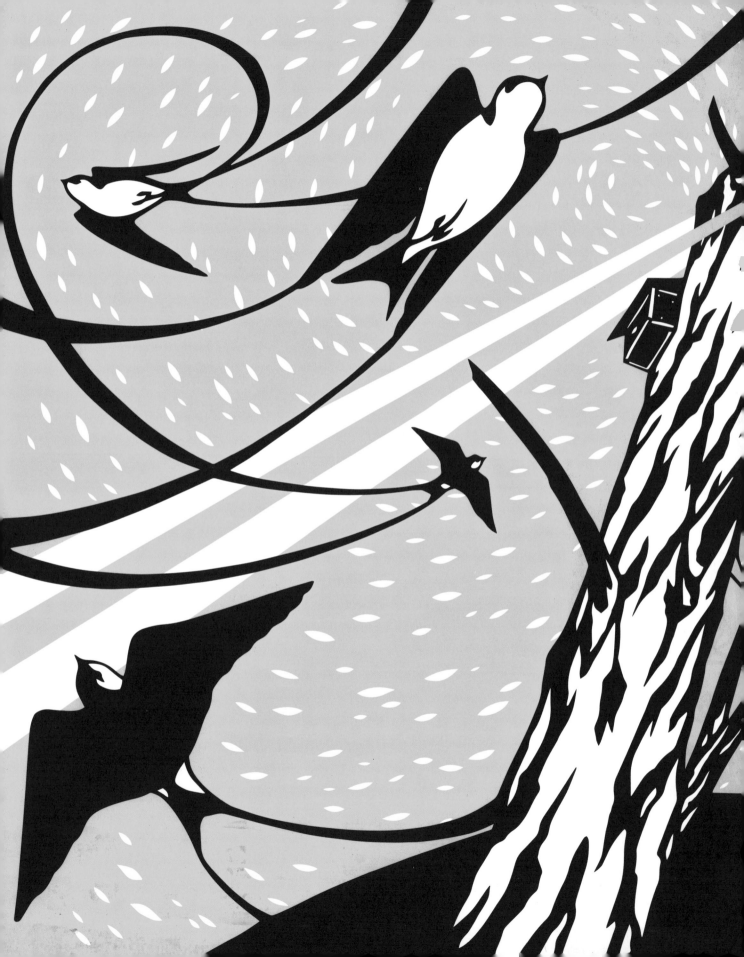

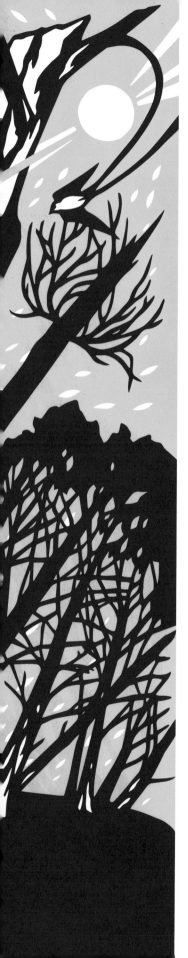

MYSTERY

The swallows come to my house last. Two pairs. They are the ones that glide and turn in the waning sun, and then go for one last swoop in skies free of swallow hubbub. The others packed up early while the light still had power, heading north. But the swallows that come here to live with me each year take their time. I'd like to be a swallow, one of the ones that linger and dance in the clear air.

COMMUNICATE

A beekeeper brought her ailing bees to us for shelter and hope of revival. The hives were lined along the southern side of Jay T.'s workshop. I'd wander up to watch the bees and Jay T. work, and I would feel OK about pausing and not doing anything besides wandering, because someone was working, a lot of someones. Here, there was industry. And I, just a hopeless gazer and time waster, was redeemed by their focus and production.

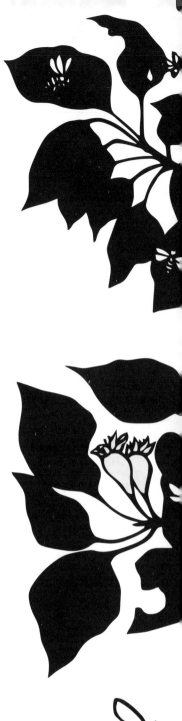

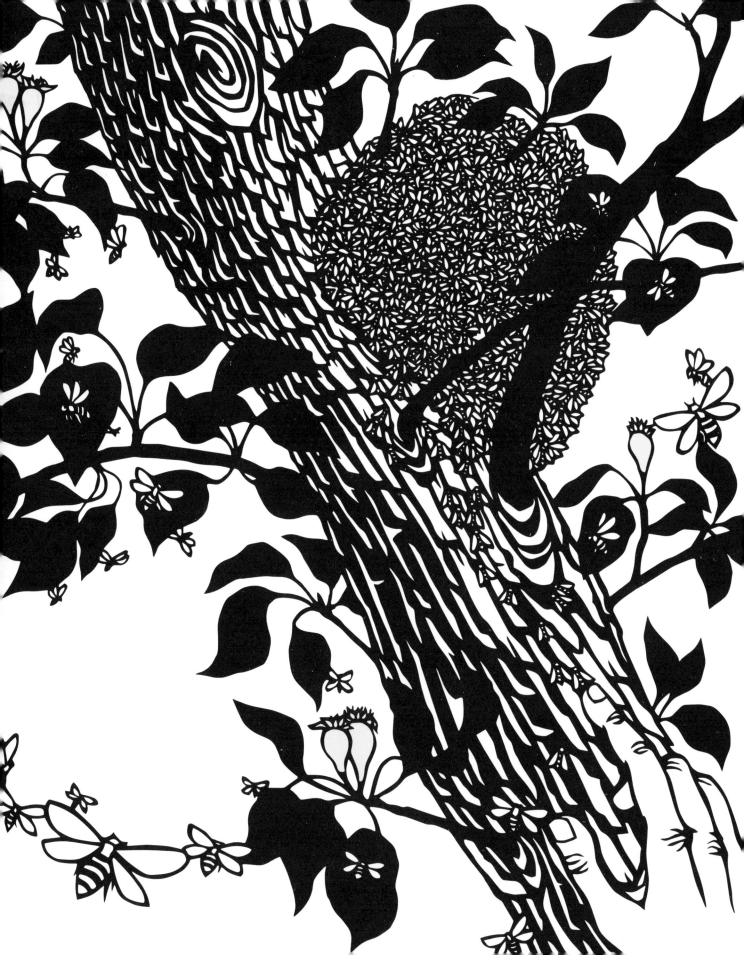

THRIVE

May Day! We race down to the beach and improvise an existence outside the realm of the Overculture. We make flaming torches out of hazel tree limbs wrapped with rags dipped in olive oil. The rituals of Beltane have filtered through time, and we cobble together enough ancient memory to leap over flames as the setting sun heralds the beginning of summer.

INSTIGATE

On May Day we make crowns from ivy and adorn them with the earliest of flowers. We wave red flags on the beach and pretend that we are our mothers smoking cigarettes while the next generation watches with wide eyes.

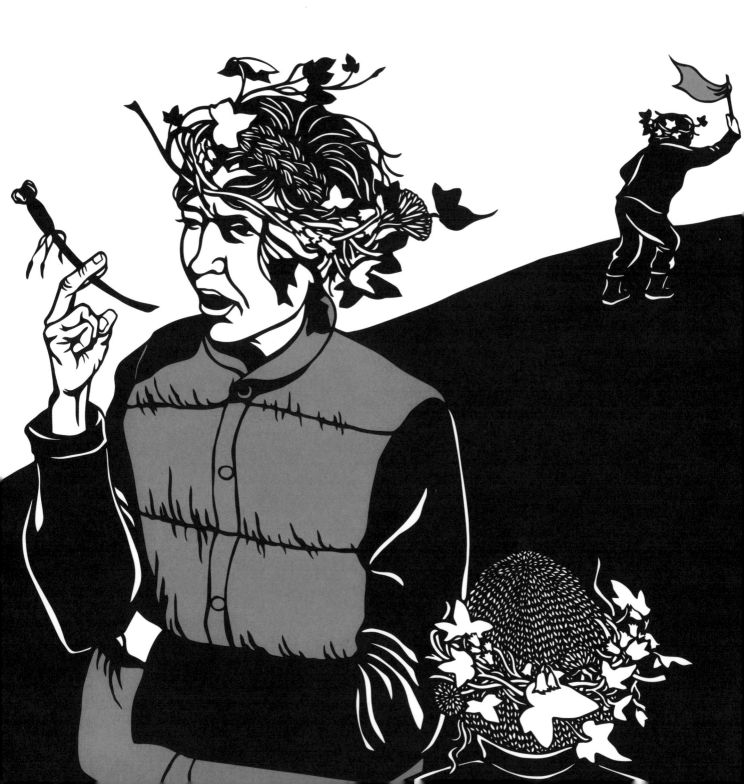

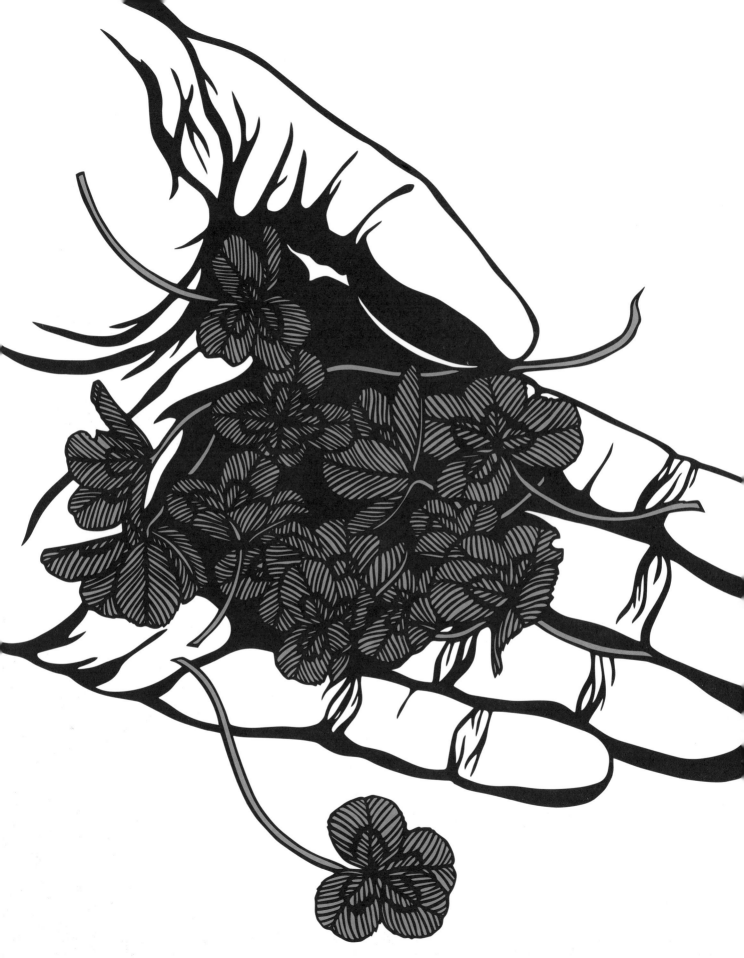

ENOUGH

I have a super power. I can find four-leaf clovers, heaps of them, handfuls. When I was young, I pressed each one in my dictionary and then made Saint Patrick's Day cards thinking that it was a holiday worthy of correspondence with an untapped market. Now I fill my shirttails full of clovers to send to a friend who is meeting death too early, and I can't find enough to stop it from happening.

RECORD

I keep a list of birds that I see at my home.
The list is started fresh every year. In 2020 we
spotted a record high of ninety-two species.
One day, as I sat in the window seat, gazing out
and practicing for my future career of profes-
sional watcher out of windows, I saw four large
white birds gliding across the sky. I grabbed my
binoculars and ran outside yelling, "Pelicans!
Look, Jay T.!" Just then his phone rang. It was
Lanny saying, "Hey Jay T., look up in the sky,
people have been seeing American white peli-
cans." The next year there were fourteen resting
in the shallows. They are noticed by watchers
of the sky and recorders of migration.

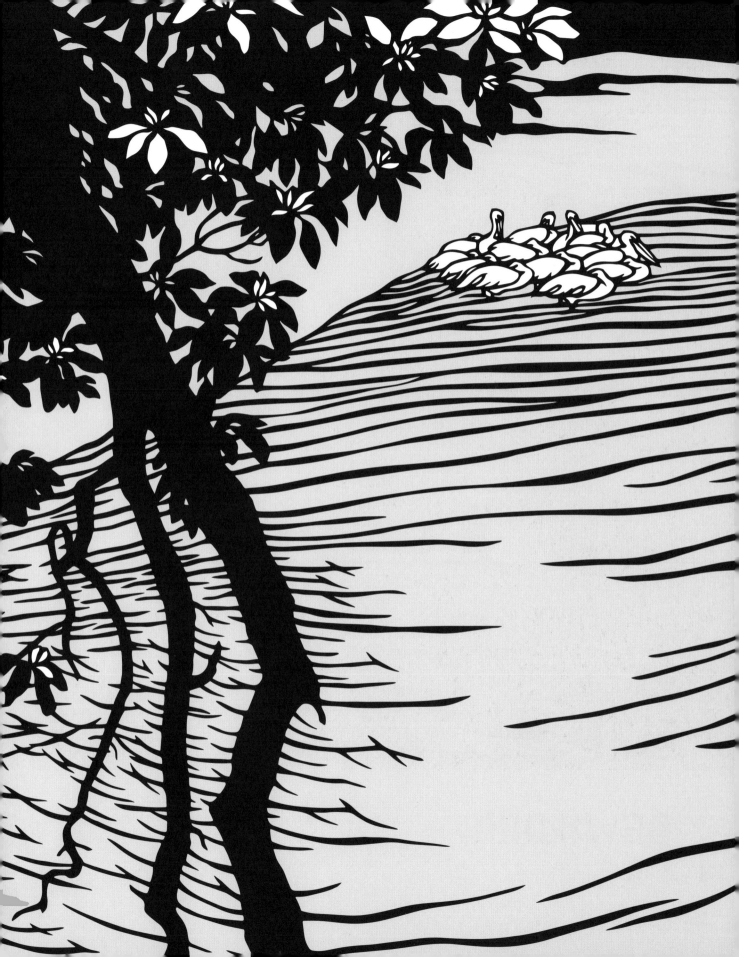

BEWILDER

From the top of Mount Constitution on Orcas Island, you can look at Canada, up into the Strait of Georgia, and the edge of the known. Life is wilder up there where the clouds are made. I dream of voyages and gather charts.

ESCAPE

There is power in this simple gesture. I collect twisting garlic scapes and wrap them around my wrists to ward off mosquitos and vampires. I feel strong. Invincible. Brave. I will eat you with them for dinner.

MEMORIZE

Ki-Ichigo No To Oi Kioku O Tsumi Ni Keri.
(Picking raspberries of distant memories.)

By Takao Ozaki.

Mother and child entwine past, present, and
future. The straw mulch looks like *kanji*. We try to
read the few Japanese words we had memorized.
We feel the sun and eat berries still cold from
the morning.

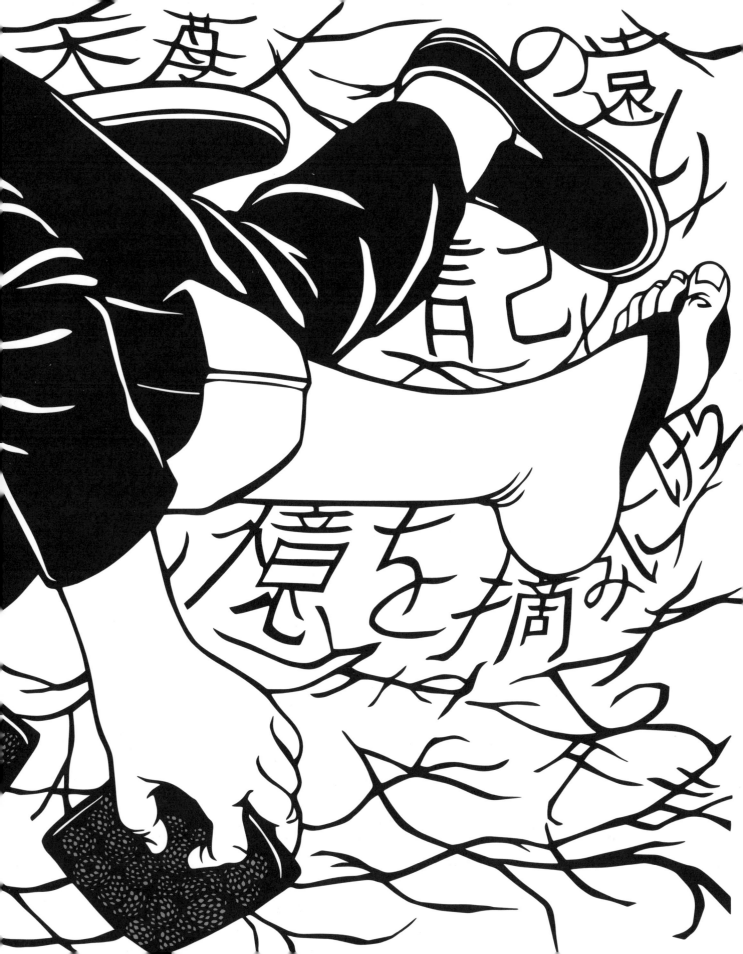

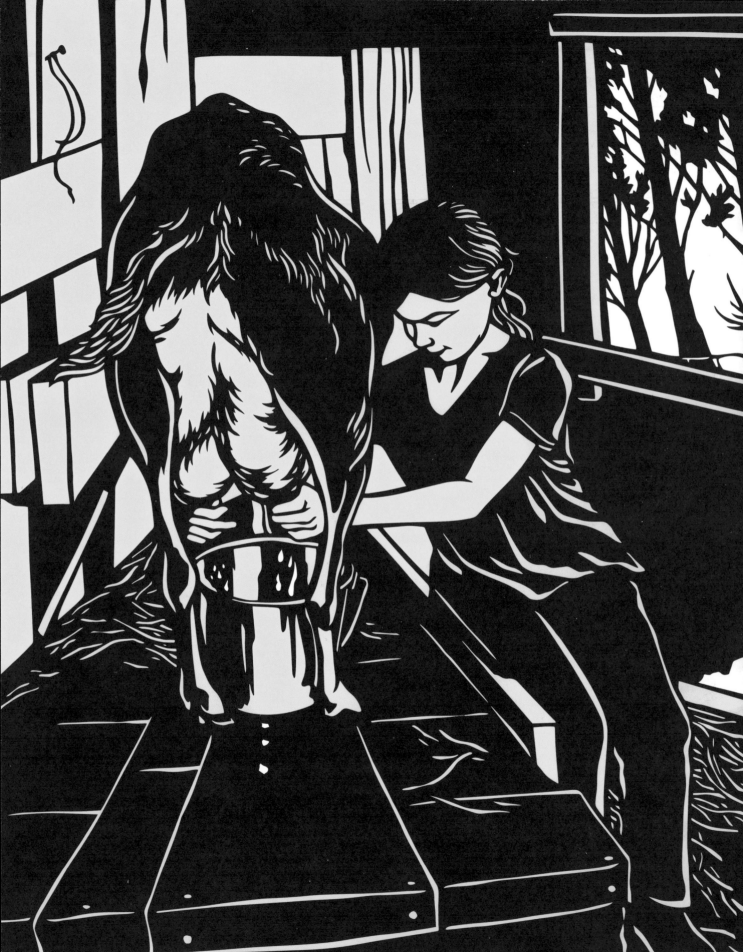

REPLENISH

There is a small barn in Anacortes, Washington, a place where I go to replenish. The gate is an old sign with Gothic lettering that reads "BOOKS," a relic from the old business. Here, nothing is original. This barn is cobbled and hammered and layered from generations of stewardship. It is home to some goats and chickens, rats and spiders. It smells of dust and hay, musk and milk. I duck my head and follow Bret through the darkest corridor. He could move through this space with his eyes closed before he was born. He is creator of and created by this place. Bret introduces Sophie to the goat Bella. Sophie demonstrates her 4-H technique; her head resting on Bella. This is their first time together. This barn is here to return to. It is a standing invitation.

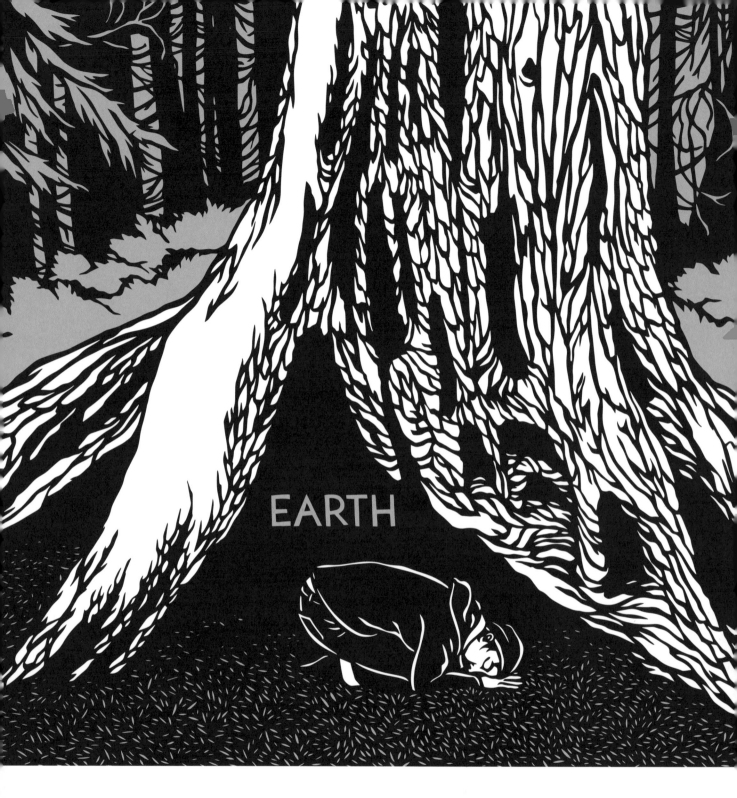

EARTH

I taught a class in Sitka, Alaska. We'd gather in the mornings to examine words and create images. In the afternoon, we would walk among giant Sitka spruce trees. I crawled under one. Scared and apprehensive, I was aware of the towering weight above me. But the moment I entered the dark, soft, damp root base, my heart slowed and my breath relaxed. I could have fallen asleep. If I lived in Sitka, this is where I would take naps.

JUNE 2018

JOIN

Maybe there is something down there
besides potatoes. Dive in and see.

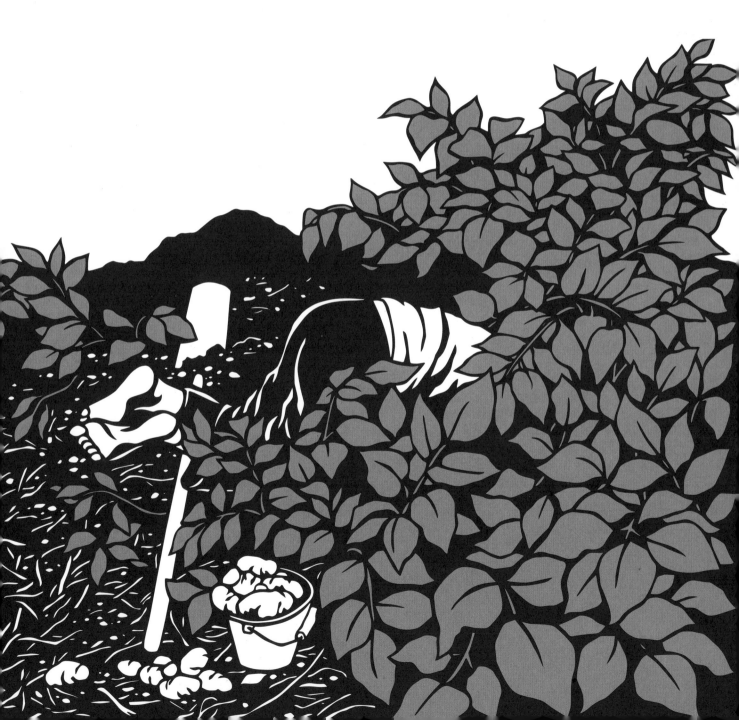

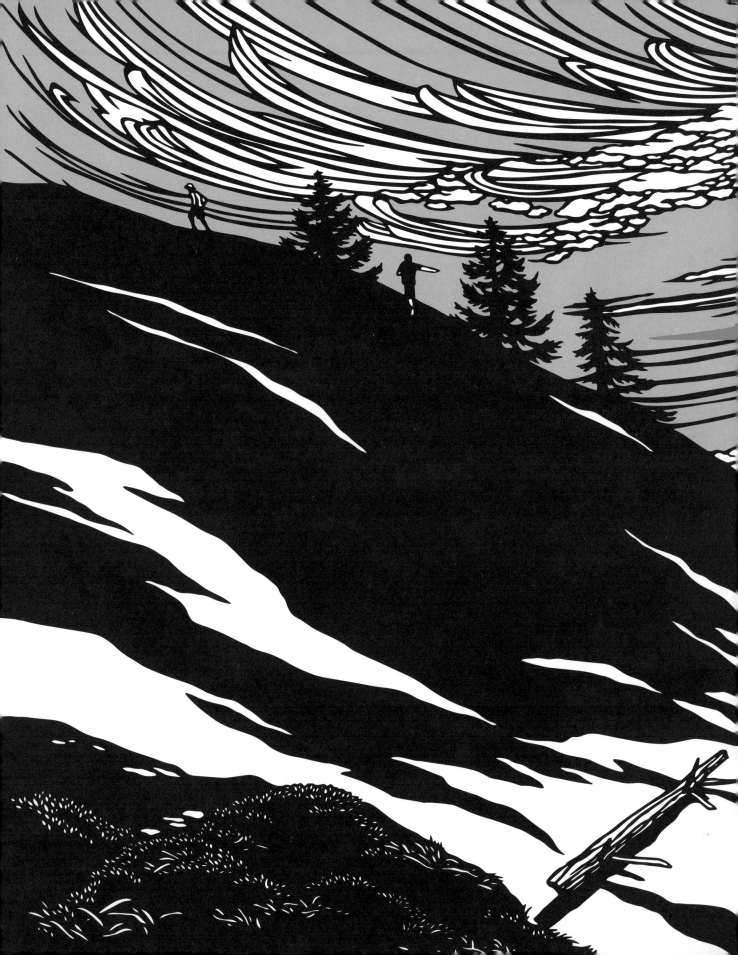

CHANGE

We have been slogging up this hill, convinced that this is the way to go: upward, always. But the kids, they see the mares' tails in the sky. They feel the breeze freshening and see the clouds forming on the horizon. They point out a new path, over there. Sideways, we cut across the hill and follow their lead. In 2020, when this image was up on walls, Black Lives Matter protestors worked hard, day and night, pointing to a new way, a new call for a reckoning on racism and the need for profound change. Over there. Let's go over there.

RISE

Babies are hidden in the grasses, and we race by unaware. We rest our bodies by running in the hills of Marin, California, before we drive hundreds of miles more.

EVER

What is *ever*? At all times, always, in any way, but especially, in this way. Though I am not sure why I am eating raspberries with a fork.

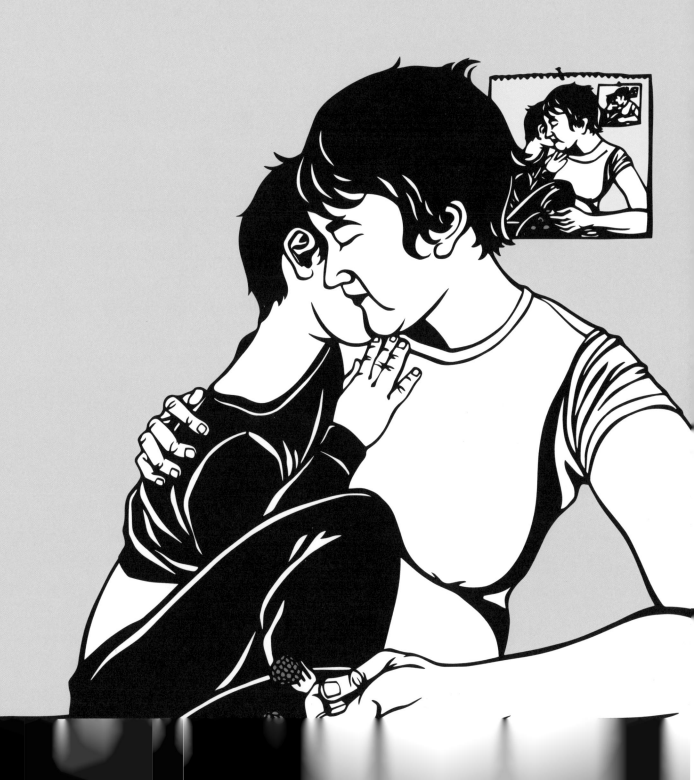

CELEBRATE

I'd worship a summer goddess with ceremonial sunset swims while the tide falls. The laughing songs would fade into silence as I float with my eyes in the space between sea and sky.

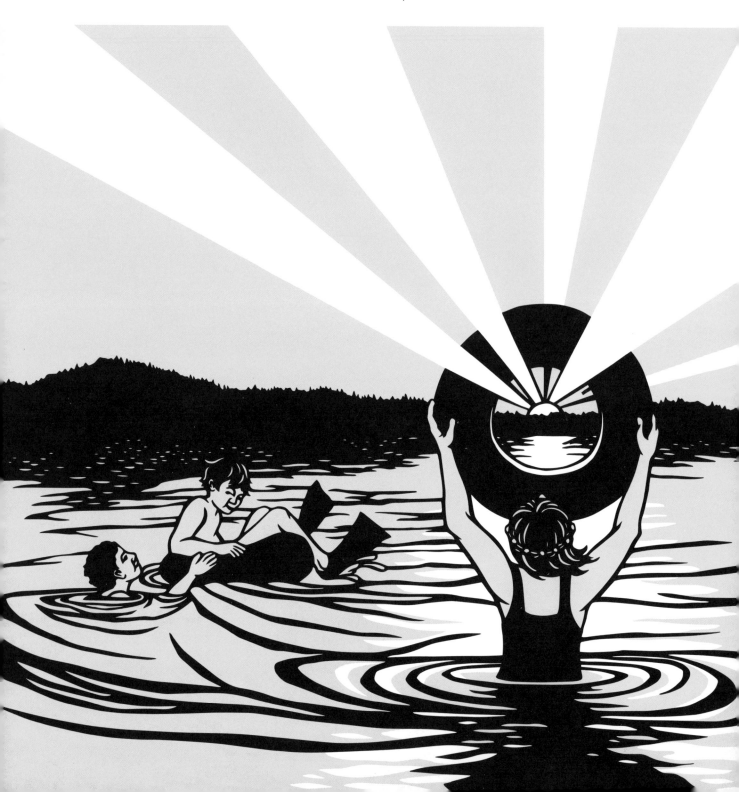

At Staircase in Olympic National Park, the water is straight from-a-glacier cold. We snorkel and swim with salmon until our heads ache and our limbs no longer bend. We drape our bodies on warm rocks while dippers continue to dive in and bob out of the clear river.

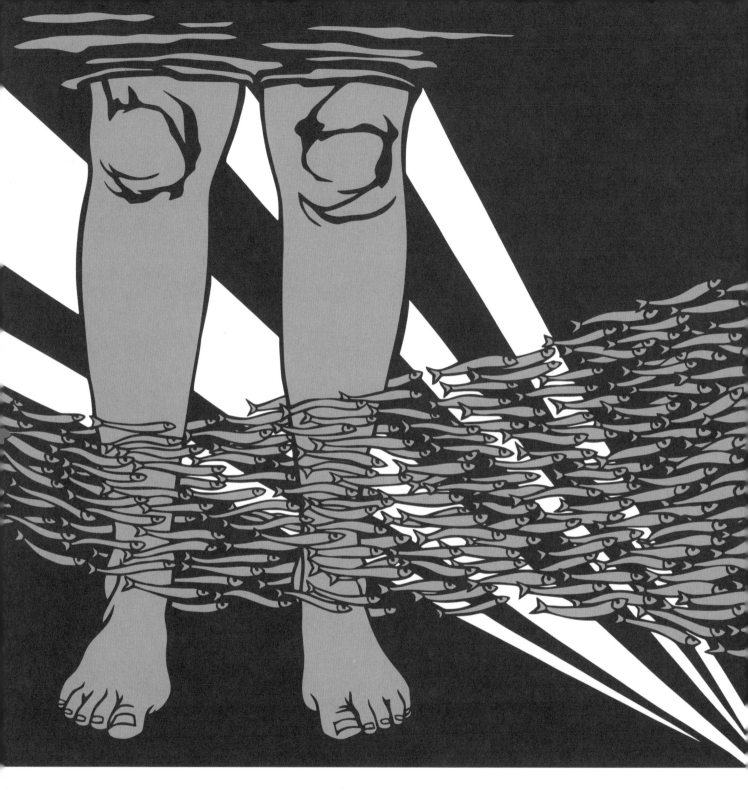

TIDE

They swim past me, mouths open, filtering the unseen. The line of fish streaming by is beyond count, yet I cannot catch a single one. The fish accommodate my body and file around me, unceasing. I cannot stop the rising and falling of the tide.

JULY 2018

INVOKE

The waters are rising, and our only plan seems to be to protect our children with magic circles.

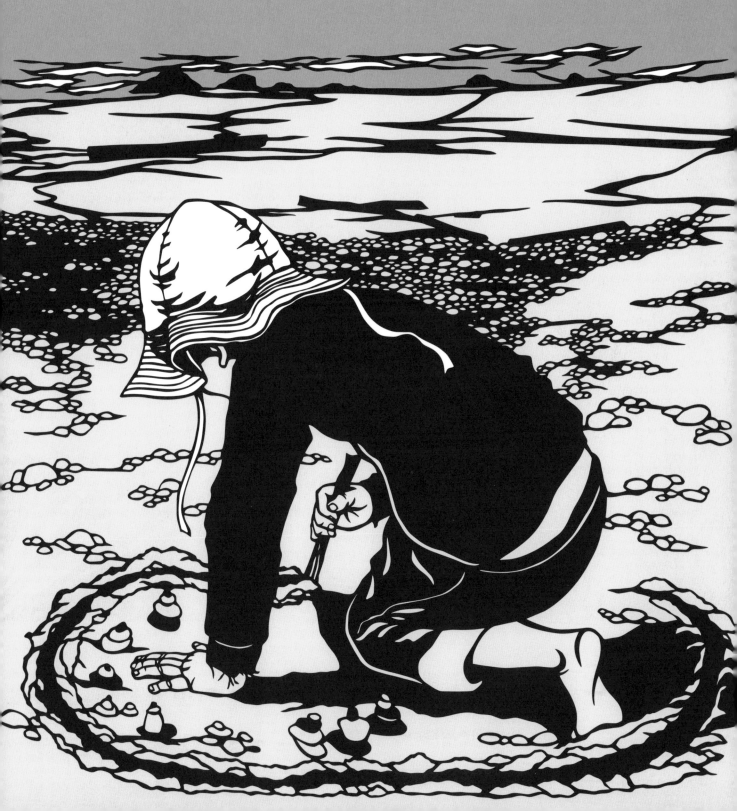

YES

I could dive into that lake again and again regardless of the occasional belly flop. The water is turquoise and clear. One of these swims, I will swim to the island in the middle. But today I have no takers to swim with me that far, and we are miles from any home; we have hiked an hour away from the boat, and there is no one else here except those two guys, one from Seattle and one from Italy, with a bug zapper, lots of diving advice, and warnings about leeches. We become fast friends for the day in the way that wilderness makes any similarity binding. But I really came here for a silent conversation with a body of water. Molecule by molecule, it is a reunion that I always say yes to.

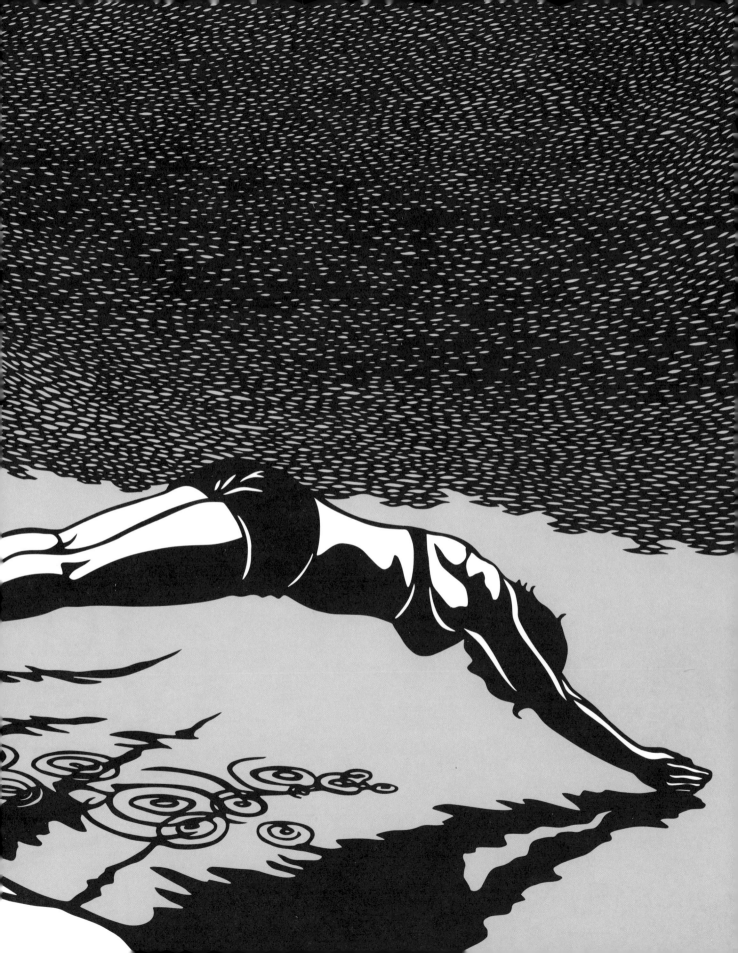

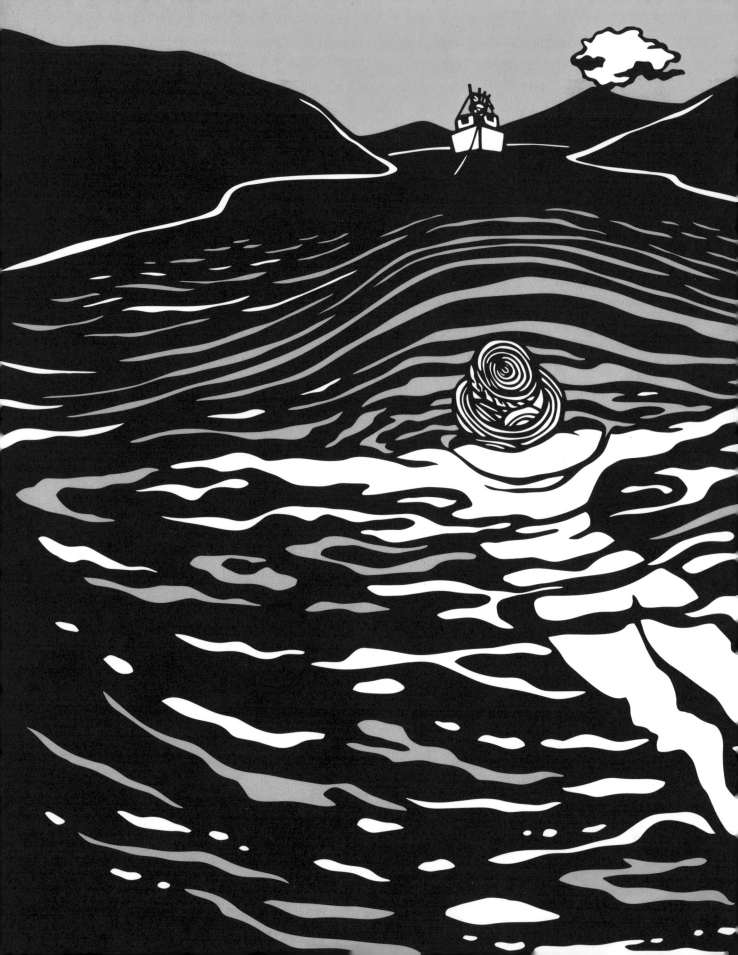

ENCORE

It was almost my birthday. The water was still.
Night was falling. We were anchored far north.
A few motorboats were tucked in the bay as well.
I started swimming, and a man stepped out
onto the deck of one of the boats and began
playing the bagpipes. You never know that you
have always dreamed of something like this,
as it is so completely improbable, but as soon
as the vibration filled me, I knew it was a dream
come true. I swam. He played. The sun set and
the music stopped. The next day they were gone
on the early tide. It was my birthday, and I was
hoping to request an encore. A few days later,
we pulled up the anchor and sailed home. When
we came into communication range, I found
out that my grandmother had died the night the
bagpipes sounded. She had lived one hundred
and four summers.

The moon makes a path on the still-water nights of heron hunts, and I follow. This never happens, or maybe this always happens. It could be either. It is so magical that it is impossible to connect with, or it is so magical that it is a returning ritual of power and is the only way to move on to a new day. I swim into tomorrow.

INTUIT

RELEASE

There is a place on an island where I love. I stay there long enough to sink into the earth, feel the stinging itch of cuts from the tall grasses, and see a bat shake the scales from a moth's wings.

GO

I live near blueberry farms, and the best way to get there is by bicycle. It is not the best way to return with a bucketfull of berries though, so riding my bike there is usually more of a dream than a reality. The bike gang I always hope to meet there never arrives. I have many imagined possibilities that are never actualized. *Ding, ding*! My bike bell announces that I am here. The bushes rustle.

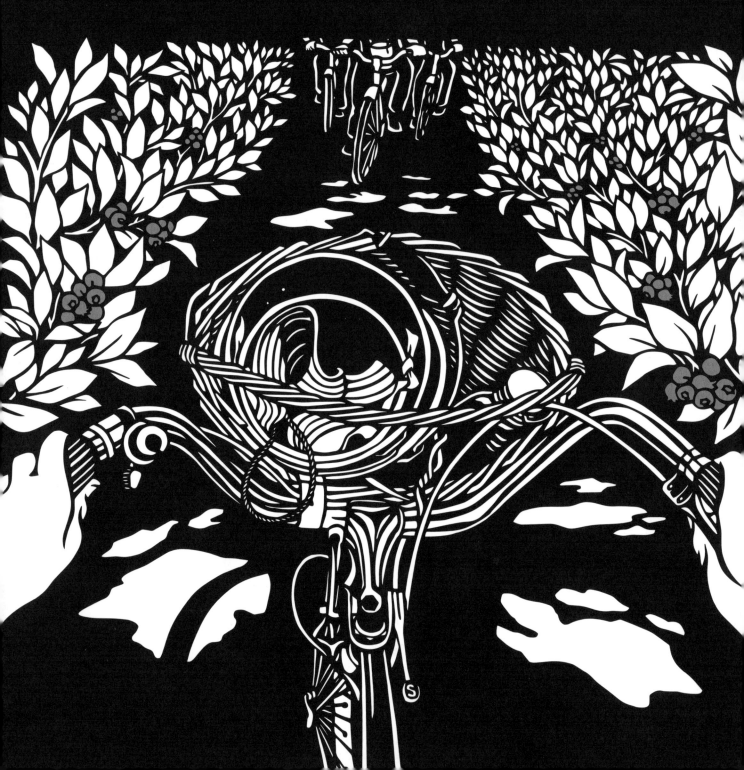

What did it feel like to be carried across the water in the first boat? What does anyone's first time in a boat feel like? You instinctively reach down and skim your fingers across the surface of the water. The water stays still—it is you who moves forward.

FORWARD

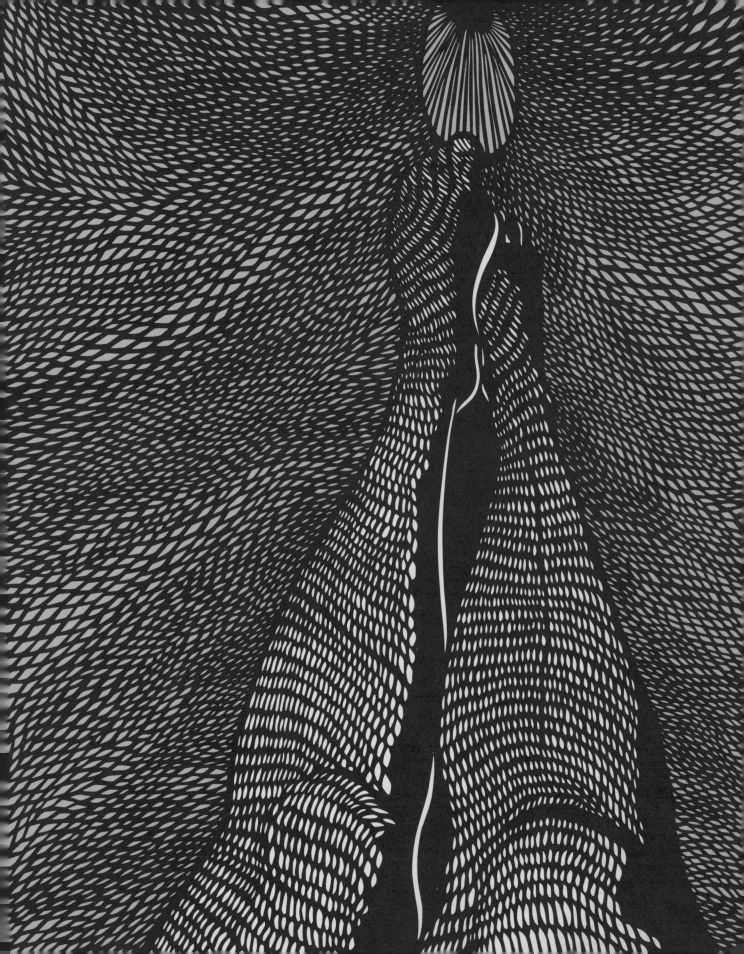

NOW

There is a challenge in each square of black paper. Every week I sit down and try again, never quite hitting the mark. But sometimes I get close enough to lose all thought and flow into the making. Lying in a hammock is a bit like this. It takes a long time to squirm and finally settle into a place where you are held, where you can relax and trust. And then someone walks up just as you are about doze off. That moment of ease felt so long.

I could divide my days into working and hammocking, but they would be days of shuffling, adjusting paper and thoughts and my body. That's why I'd add swimming. Swimming is both thought and body drifting without the need to find position or perspective or focus or challenge. I try to swim back to *now* and the hammock, but I cannot make it. My thought tendrils are carried away by the current.

REFLECT

The water here is so still that the reflections of the waterline make trippy patterns. Rock and water collaborate to create designs that then disappear when a mink dives in for a meal of crunchy crabs. But this has never happened to me. I have never been invited to swim with an octopus no matter how lost in thought I am.

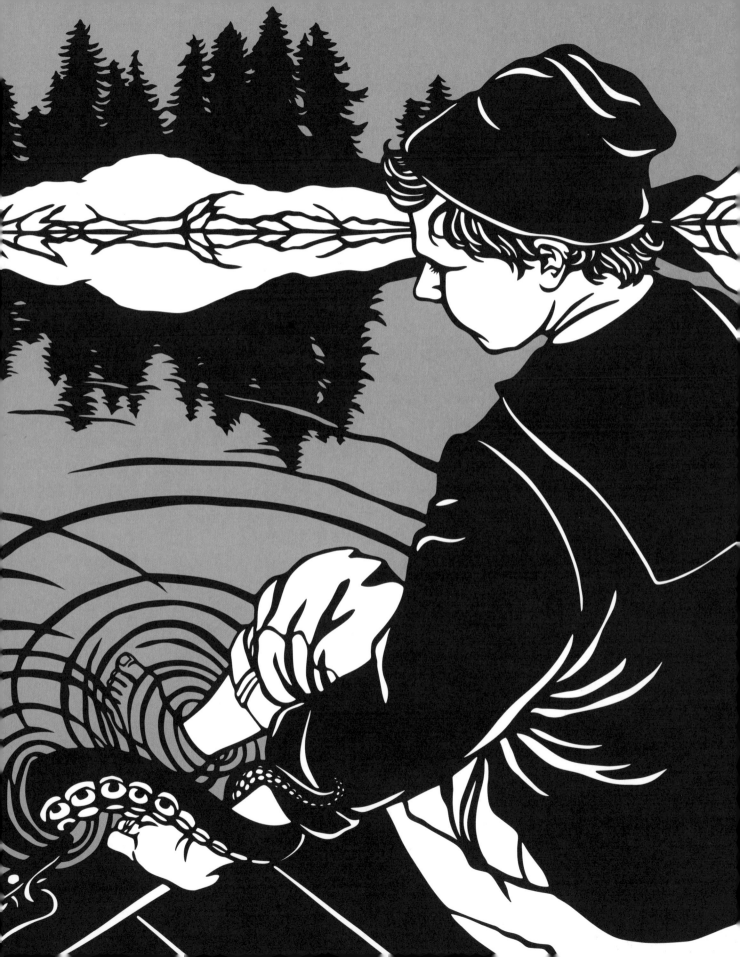

SUBVERT

A crowbar, shovel, and mole might do the trick as suburban sprawl no longer creeps but explodes, decimating all

LINGER

I remember peaches late to grow that still held the last of the sun's warmth. I travel to this time over and over. My arm reaches for the heavy, warm fruit. I know how much summer weighs.

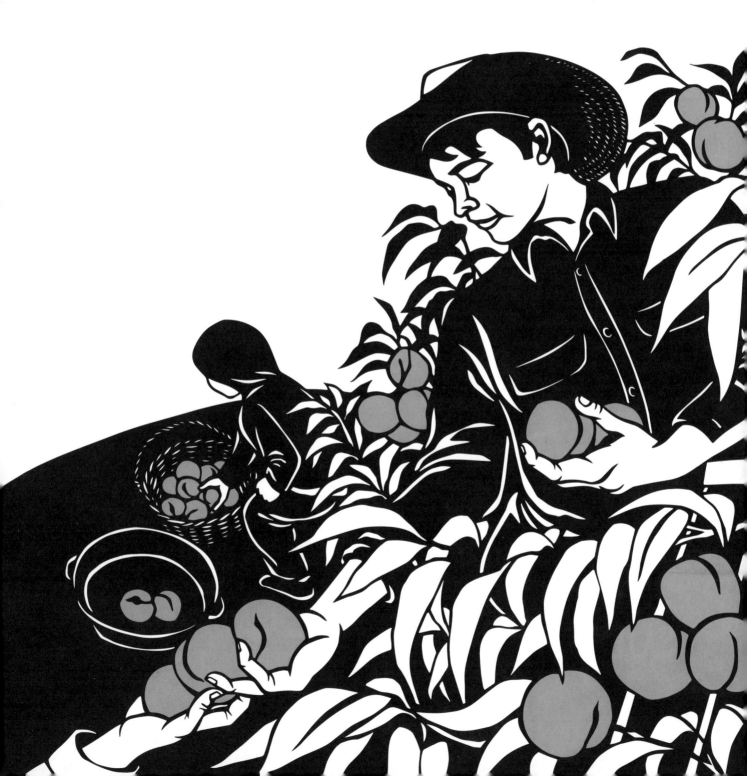

DEFEND

It is September, and the woolly bear caterpillars are on the move from one side of the road to the other. I live on a quiet little street next to a forest. Every day I find squished caterpillars on the pavement. When I drive home in the afternoon, I see caterpillars on their journey. I stop my car, get out, and scoop them up one by one. I drive farther and find two more. By the time I come home, there are caterpillars crawling on me, and I have a handful of ones that are still curled up. They resume their travels in my garden where they find leaves and logs to safely winter under.

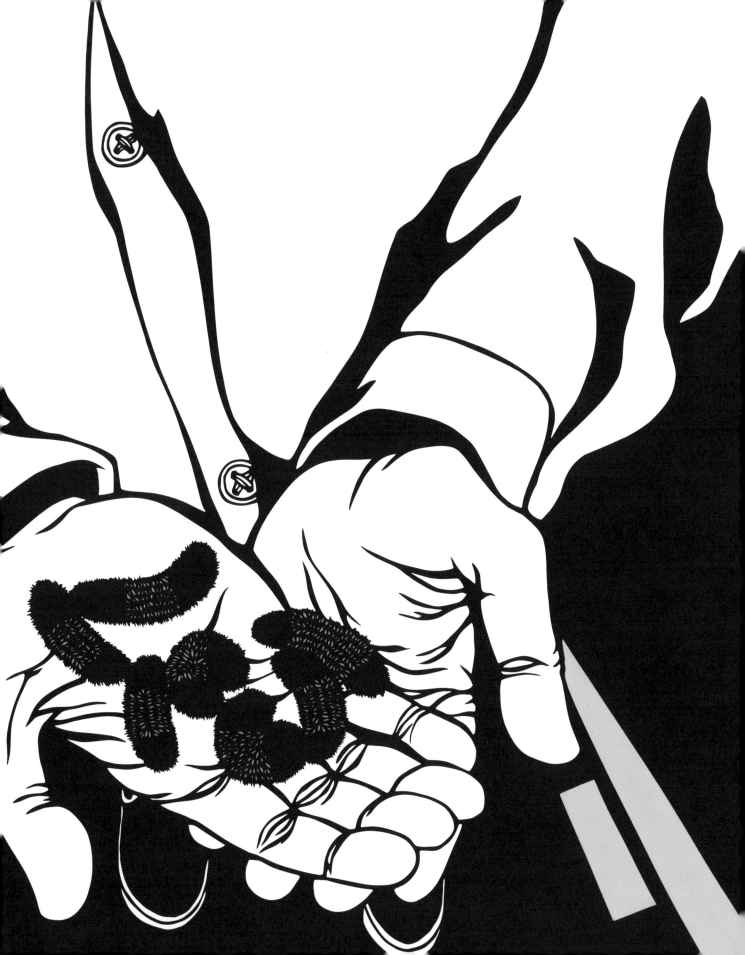

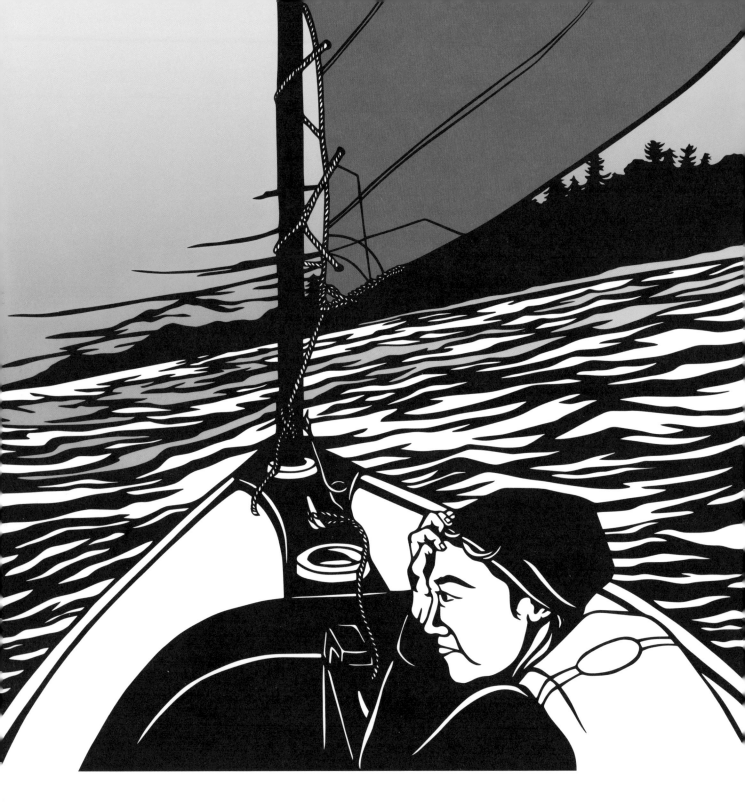

TEST

Sailing home with the sun setting quicker than the last sunset, I test my trust in this angled state and acceleration of time.

TRY

We find balance by making small adjustments to our bodies in space. When balancing on a stick, there is trust in materials and the willingness to experiment. We wonder if this is even possible? And I am thinking this through with my own perception. There was no consideration of balance, experiment, or wonder. Hatcher found a stick, and there was only trying and joy, free of thought, as he perched on the edge of the Pacific Ocean while the sky turned amber from wildfire smoke.

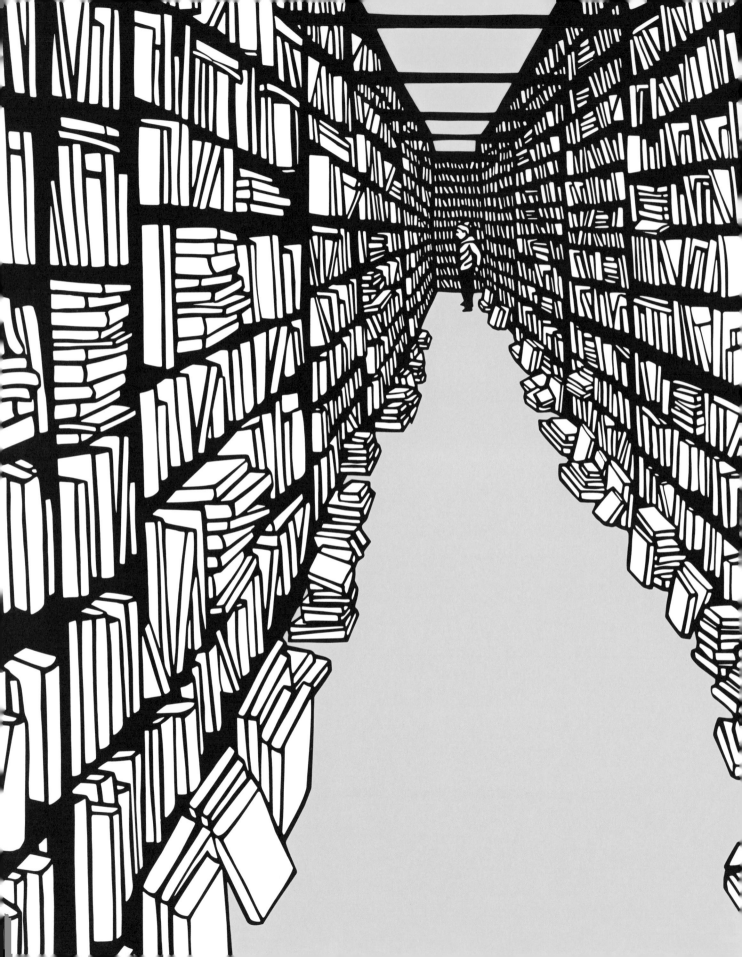

LIBERATE

All the books! My favorite used bookstores are labyrinths of shelves where every book that was ever made are stacked and jumbled. Each book is both a story of the self and a contribution to the collective tale. There are so many ways to be.

FIFTEEN THOUSAND YEARS LATER

Fifteen thousand years or so ago, a sheet of ice a mile thick altered the land where I live. The glacier's weight and motion ground rock into valleys. Melting waters carved away more, and the sea slipped into inlets and bays. The first inhabitants of this land explored the new waterways by boat. Now, fifteen thousand years later, I prefer to go to town by water. It only happens a few times a year. To leave from my home, I need a high tide. At low tide there are mudflats that sink you to your knees. I also cannot be lazy nor have a lazy crew. When tide and initiative and energy align, this is the best way to travel. Out in the water, there is a big log that marks a sandbar of glacial dust and river deposit. The log is giant. It really did come from a Time of Giants; it is so impossibly huge and unlike any tree that will ever grow again. It is chained and anchored. It is wild and dangerous. Cormorants line up on it to dry their wings.

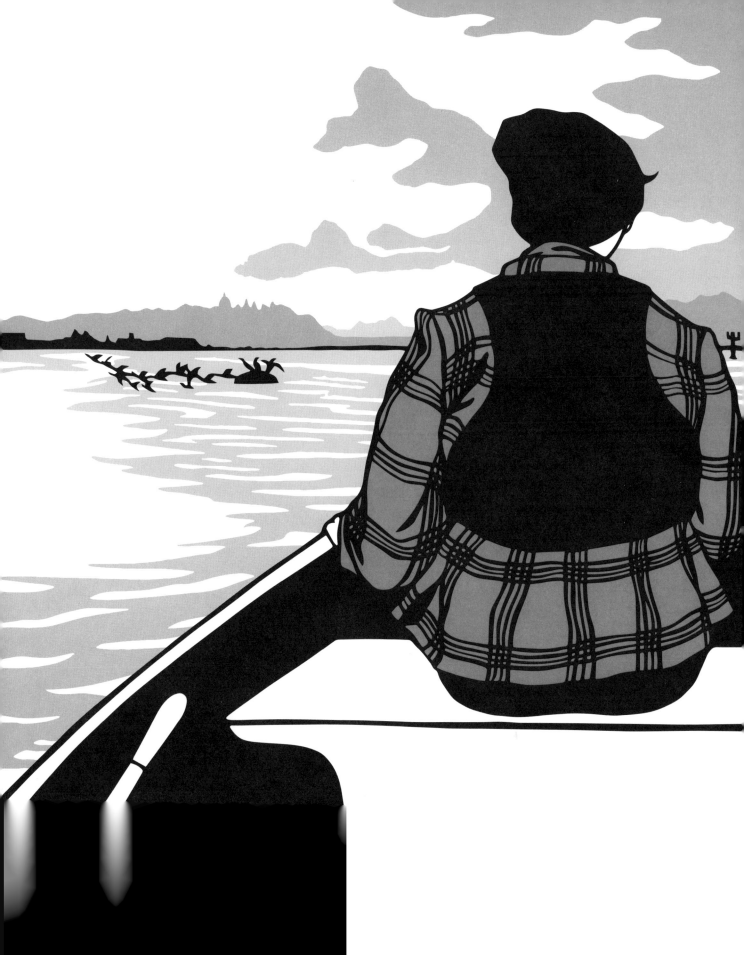

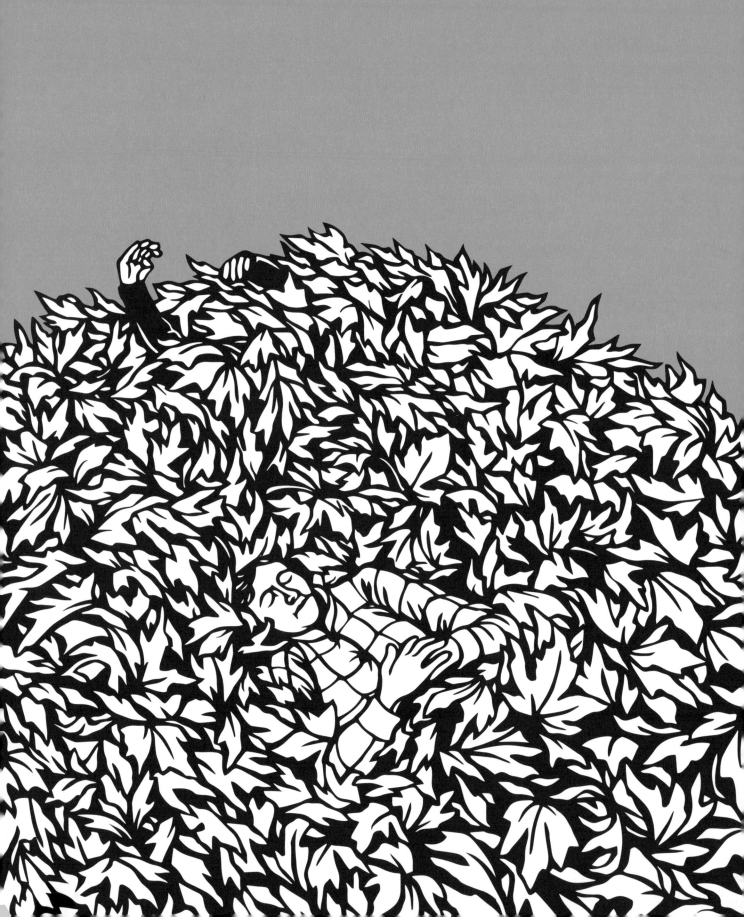

WORK

The island has a maple tree. Each year it grows
enough leaves that when they drop you can build
a seven-room home to bury yourself in and
sleep all winter; meanwhile, the world does its
work on each leaf, turning them into particles to
feed the tree and build more leaves next summer.
We are lost in this work. It is best to lie down and
wait and see what winter crumbles apart and how
it can be reused. There is work without toil.

AWAY

Thirty winters ago, there were thousands of western grebes whistling and diving and feeding in huge rafts in the waters of my home. In 2014, I saw *none*. Zero. In 2015, on September 27, I saw six.

Is this hope? Six is not three thousand. Six is not five hundred. Six is not one hundred. But it is six. And these six western grebes are beautiful, and I made a picture of them, their red eyes slipping under the water. But is this hope?

How can we note this dwindling if we are not sitting on the beach, waiting and hoping? We are driving in cars with windows too fogged up to see, and it is dark and we want to go home. How will we know that there are no western grebes if we don't even know what a grebe is? If we don't know that they make floating nests and that they bond by dancing together with waterweeds dripping from their bills before they run in tandem across the surface of a lake. How will we know if we don't stop to notice what is here now?

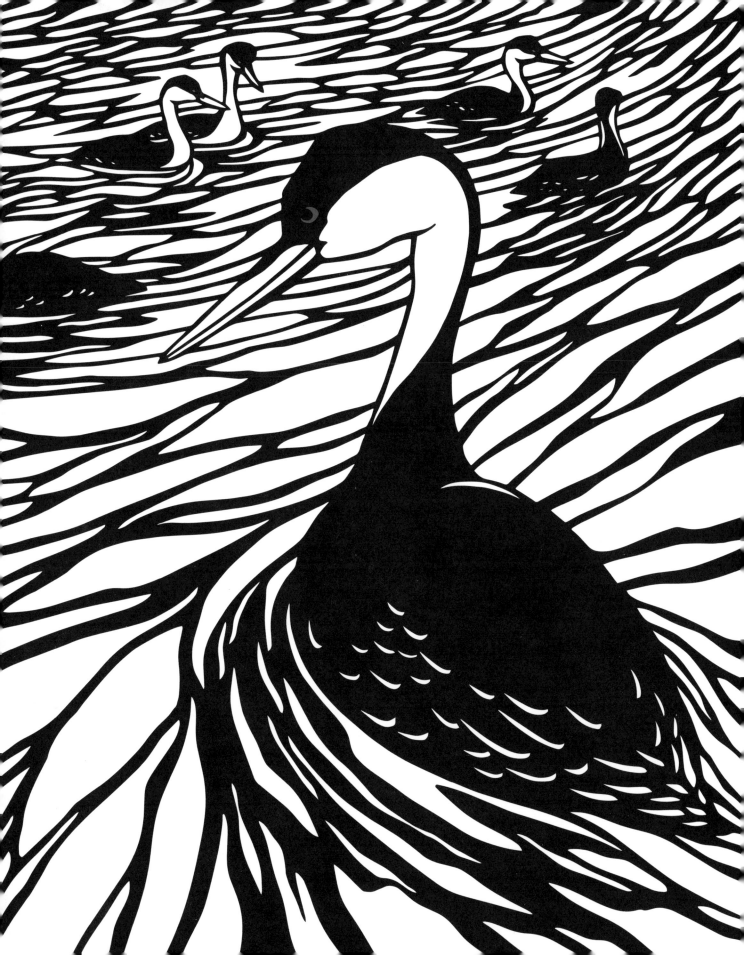

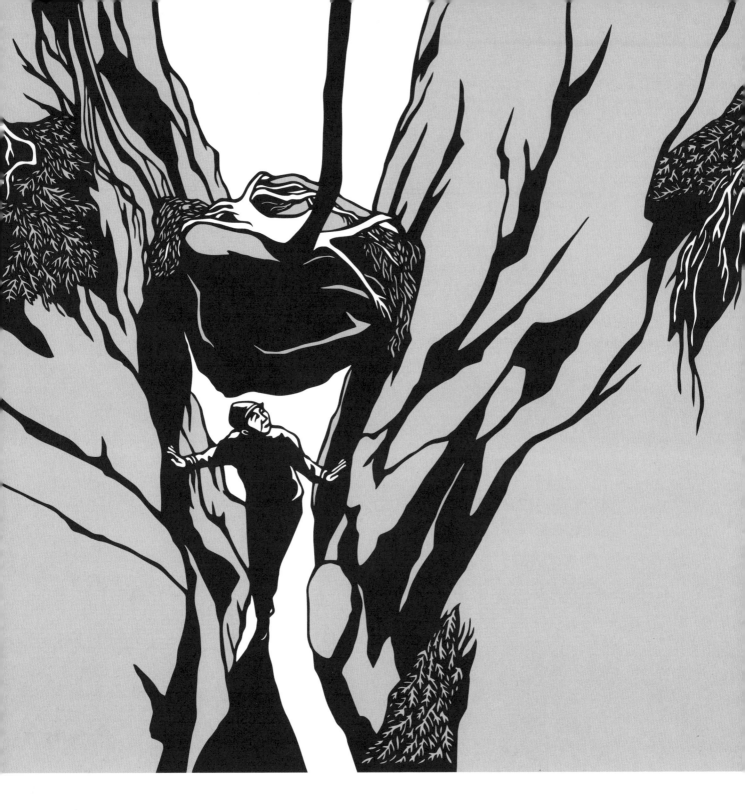

RISK

This rock is on a trail in Sitka, Alaska. It has been waiting there for a long time. It is a portal that transforms me for the journey ahead.

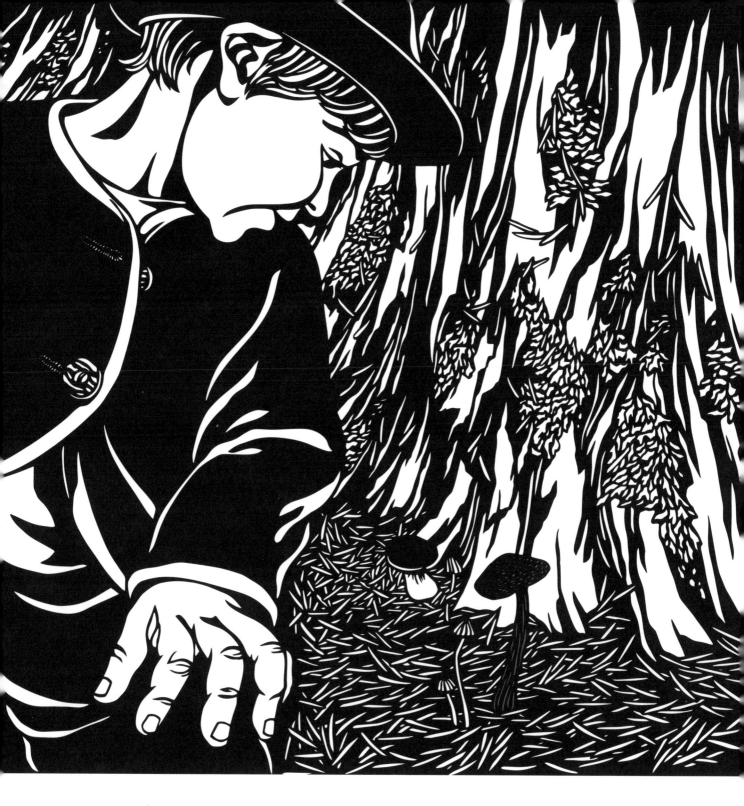

CONSIDER OTHERS

Violet cortinarius and Zeller's bolete. We took many walks in the woods when Finn was small. I miss these walks to find little friends. How do we impact others whom we never consider?

CONTEMPLATE

What if we rowed to town? The boats *Imp*, *June*, *Nike*, and *Foal* meet with the sparkle of light from the sun or the moon. There is a pause; a moment where you hold your oars and let the momentum of the boat continue before you dig in for the next stroke. To efficiently use this power, you pause. I forget to. I mostly dig, dig, dig, splash. I need to row more and relax. Dip and glide. Turn it into mediation. Transport. Is efficient transportation the fastest? Or is it the way with the least effort? Or the slowest and most awkward? I will contemplate this the next time I row to town.

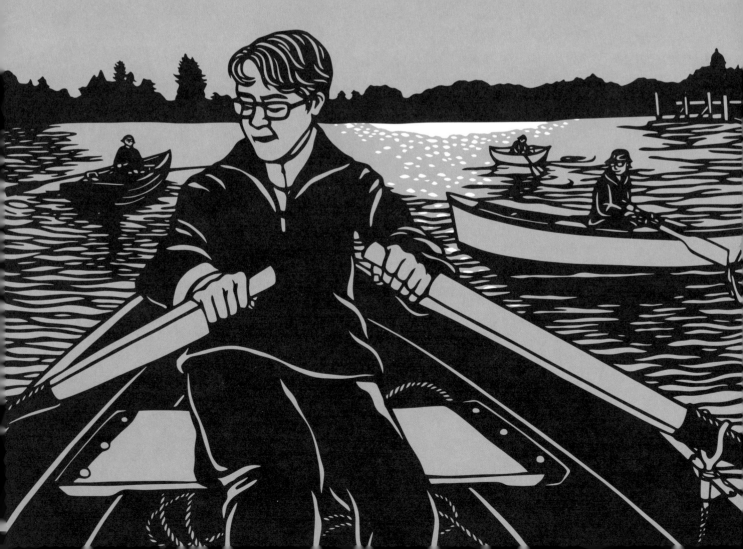

ENTER

It is garlic-planting time. We will need garlic to heal. Find a particularly robust head of garlic and break it into cloves. Poke each clove about two or three inches into the earth with the pointy tip directed upward. Then wait all winter for that clove to grow and grow until it makes a twisty flower in June. Break that off and nibble, chop, or grill it. In July, when the leaf tips yellow, pull up the garlic and braid it to hang by your door to ward away mosquitoes and shadows. Save the best bulbs to plant in October and so on. You have entered into a ritual, an agreement with time.

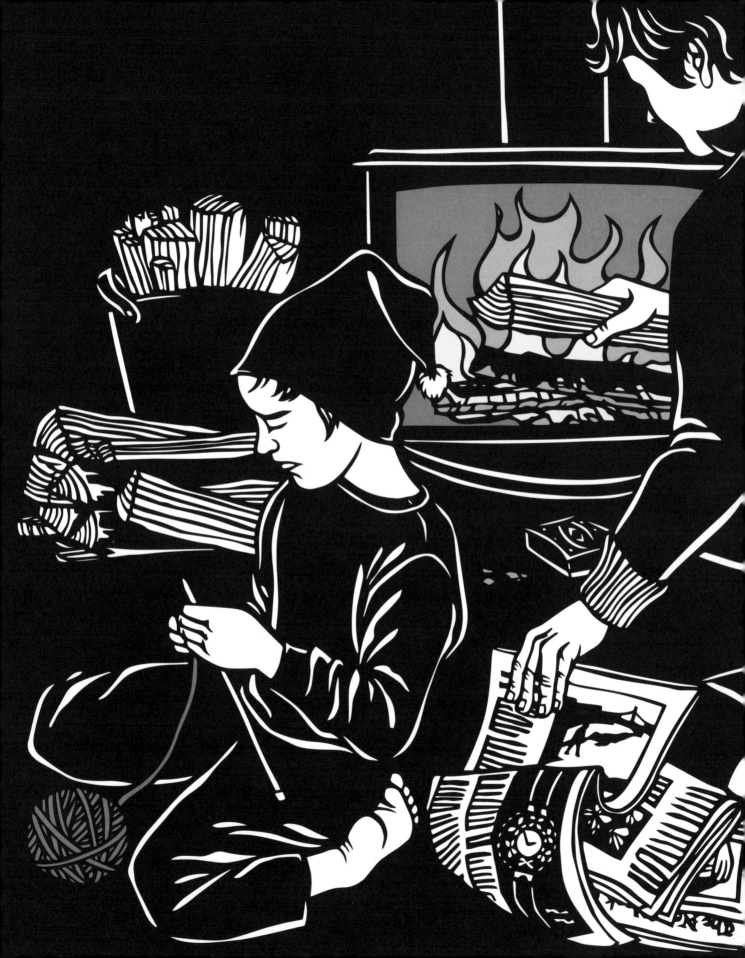

MYTH

I make fires on winter mornings. I go through
the *New York Times* and set aside articles to read,
and then I crumple up the rest to start the fire.
My neighbor leaves a stack of newspapers at my
door every two weeks. I like my news old—aged
and decanted long enough to settle into history
and dissipate or develop into the stories that
stay. I read while the fire grows self-assured and
no longer needs tending. Obituaries are saved
for the bath or an evening fire. But this story is
about the *New York Times*. There are articles about
waning monarch butterfly migration and refugees
fleeing hunger, war, violence, or climate next to
advertisements for diamond-encrusted butterfly
watches. What is the news fit to print? I crumple
it up to keep warm.

REPEAT

This is the shop of Jay T.'s teacher. Finn is plan-ing wood. I'd say practicing, but that implies that it isn't work. He is in practice, in repetition, in succession. His work has begun, and it is a repeat of the work that has been going on for a long time in this shop, with these tools, making all this dust.

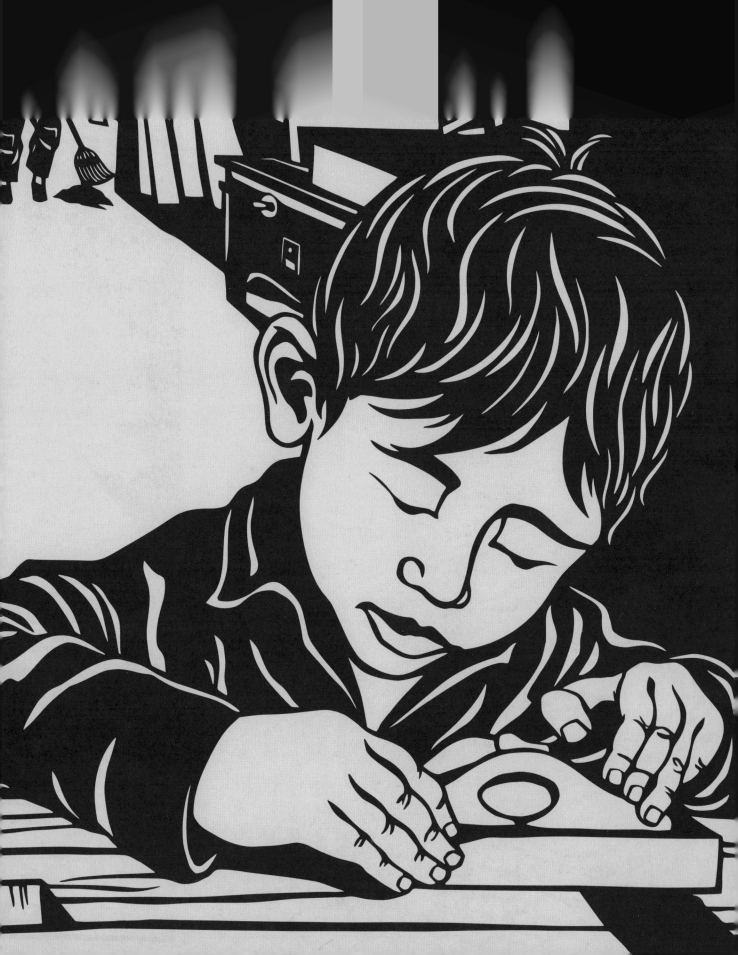

ADVENTURE

Ruby Beach is at the edge of the Pacific Ocean. Kelp is knotted and twisted by the sea. Is this how we learned to make nets? Not far north from this beach, the Makah Tribe's sea village of Ozette was buried under mud for hundreds of years ago and then found again. They uncovered centuries-old fishing nets made from twined and knotted nettle fiber.

TAKE ACTION

I once made Amber a crown of leaves for her birthday. She wore it all day while she worked at the press. When I made this picture, I asked her what she would be printing now. "Take Action," she replied.

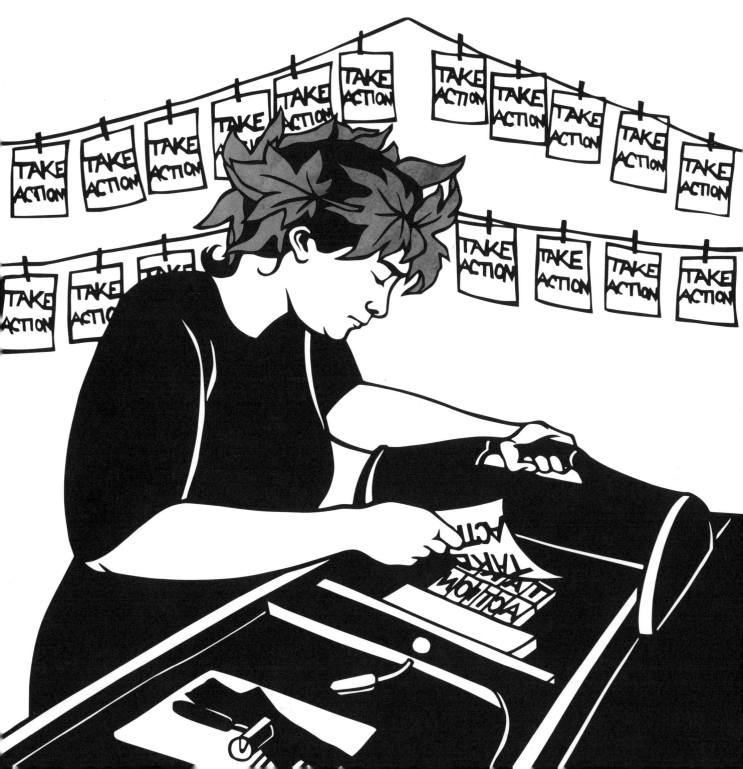

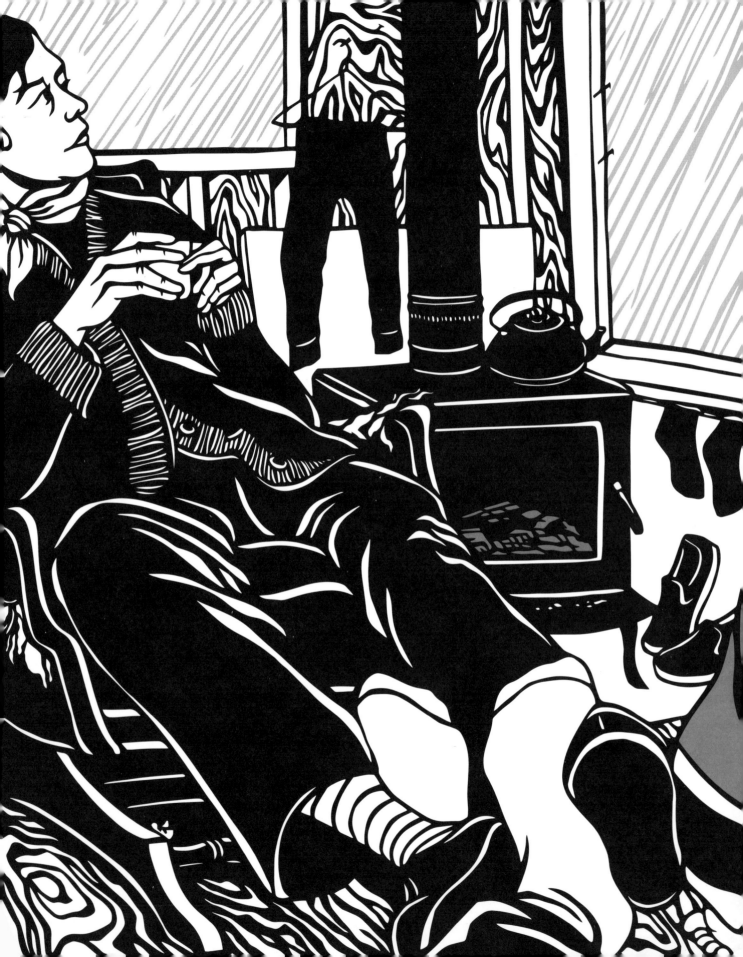

RESTORE

The rain is falling and the fire could use some tending in order to dry the woolens and shoes. Finn reads a book about boat design while we wait for things to dry out. I'd happily live in this cabin if it weren't for all the mice, but it is enough shelter for this rainstorm and to have a cup a tea. I made this picture to remind myself of this place where everything is free.

EVERYTHING DEPENDS ON EVERYTHING

A national election, a global pandemic, and a climate crisis affecting the planet equals everything—including me, including you, your family and friends, the mailman, the bus driver, the crow that just flew across the sky, and the two-hundred-year-old cedar. Everything depends on everything else doing its part. The red circle signaled Mars when I made the image, but it morphed from representing an unrealistic escape plan to COVID-19 drifting about the world and the bubbles we formed for protection.

EVERYTHING DEPENDS ON

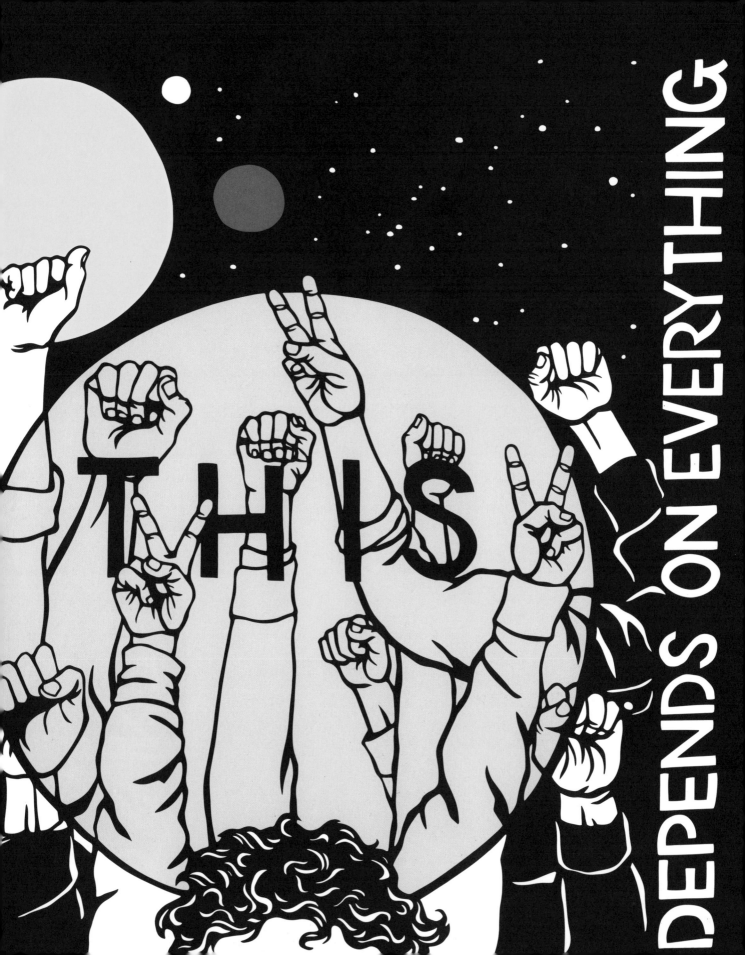

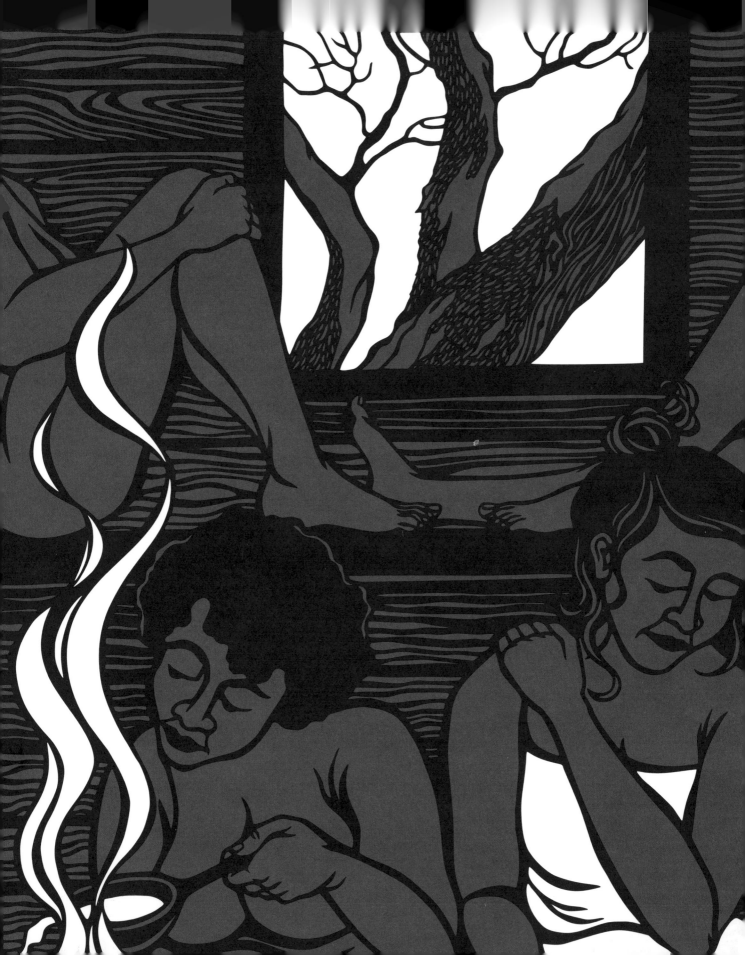

PARTICIPATE

The year 2020 will seep its way into our stories. We are longing to sweat and breathe together and the knowing that we still might not be there two years after the pandemic. Yet, we will need ladies to keep us company, to open up and listen to, to murmur and whisper with, and to laugh and cry and participate. We will find a way to do this.

COLLAPSE

Barricade! Advance! Retreat! When and where
does this begin? Where and when does this end?
The scrunch of snow grows louder. The dense
weight makes each layer harder to peel from the
earth. Green grass appears and paths crisscross
the field. Every last crumble compacts until it is
impossible to move the mass, though you call for
help and use your legs and back to push. And then
you begin again. Afterward, the field is a mess,
and you wonder what came over you to disturb
the stillness, purity, and glory of untrodden snow.
Yet, a week later, the most massive of all snowballs
glows white with cold, happy memory, and you
are glad that the snow came and went and that the
Earth continues to orbit.

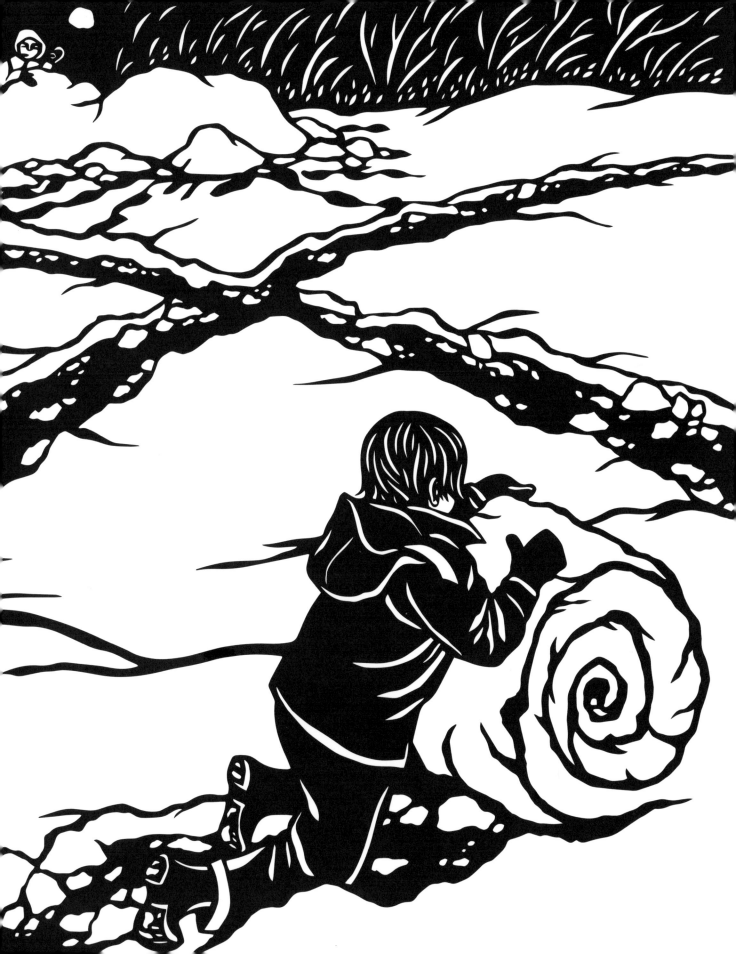

WINTER

Sea ducks are here in the winter. Buffleheads are my favorite. They collect in the evening, finding shelter together in the little bay of the beach where I live. They bob their heads and flutter their wings and splash and gurgle near the shore edge, always staying afloat. What news are they sharing? Stories? Or is it a dance to keep warm or bond with a mate?

I have started swimming in the winter with the buffleheads. I listen in on their quiet conversations and see their red feet braking their flight as they land on the water. Their tails turn up when they are sleeping like staysails. Out in this cold water in the winter, I see things new to me. When the water is still and it begins to rain hard, the raindrops form little balls that roll and skid about on the surface of the sea. I get so cold that I feel on fire. I stay in this sea dream with the buffleheads. When the water gets too warm, I will fly north.

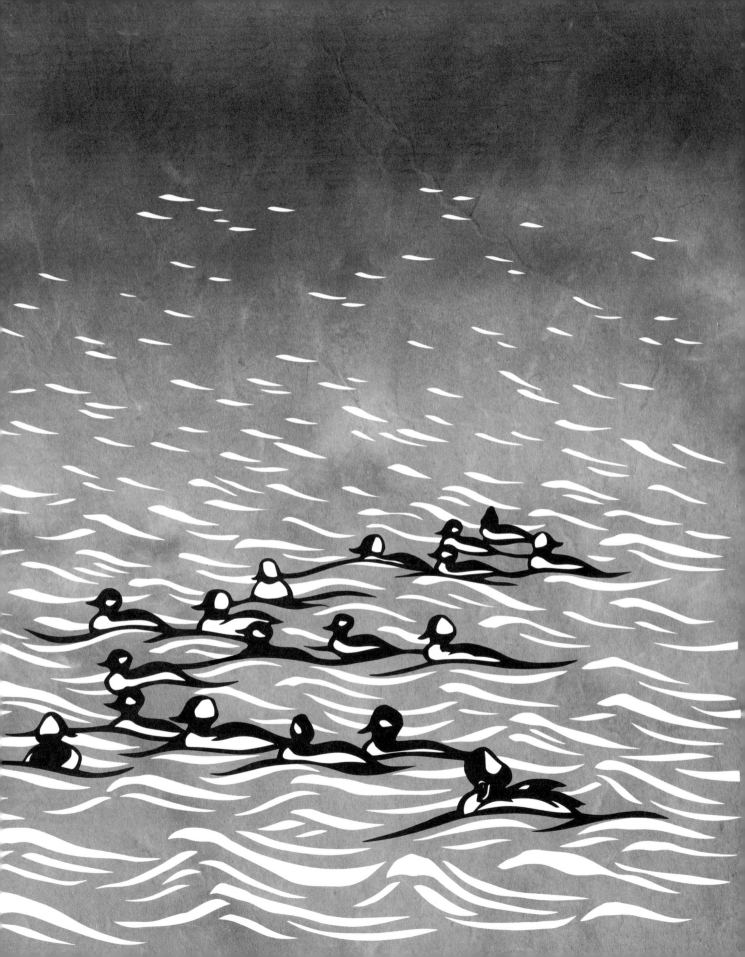

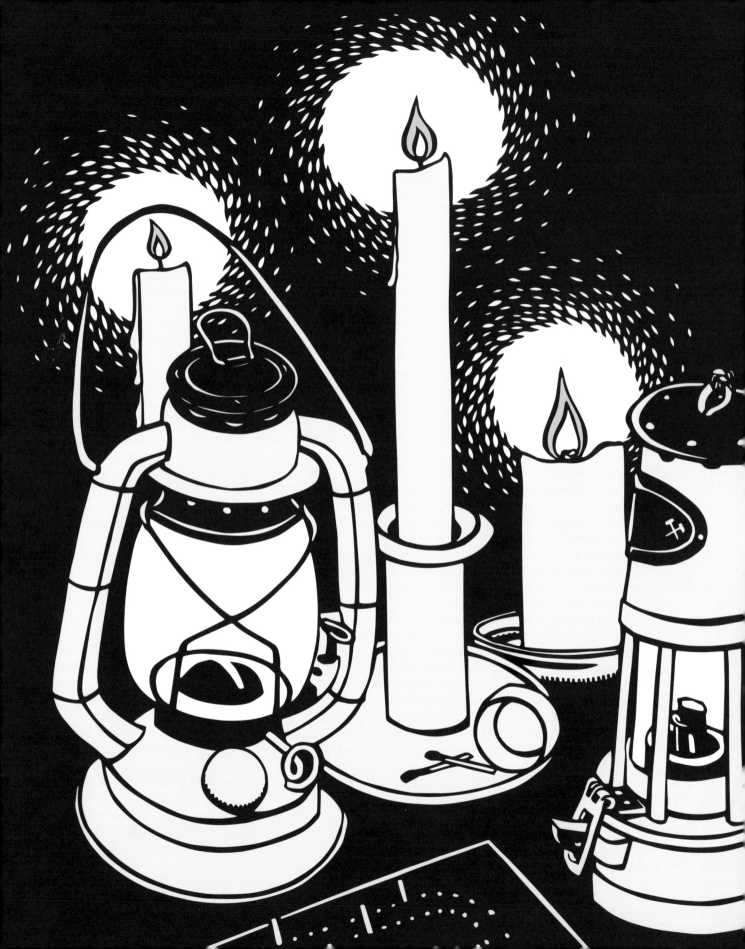

CONVERSE

The best part about a power outage is that all the sounds—the fans, the lights, and the incessant noises that amplify into mild anxiety inside me—are quieted. The next best part is that candles and lanterns are remembered and a game of cribbage begins. I want to know one thing, what are the moths of December nights?

CON NOSOTROS

December pulls me into the mountains for the annual tree hunt. Jay T. and I take the kids on a wild scramble down steep ravines, and then we claw our way back up. The forest duff smells wet and ancient. We trust tiny branches to steady us, grasping them to stop a fall or to help lift us for the climb. The kids trust us. They trust the forest. They trust themselves to wander off the trail into the woods. It is a feeling we so rarely give ourselves, this wilderness with us.

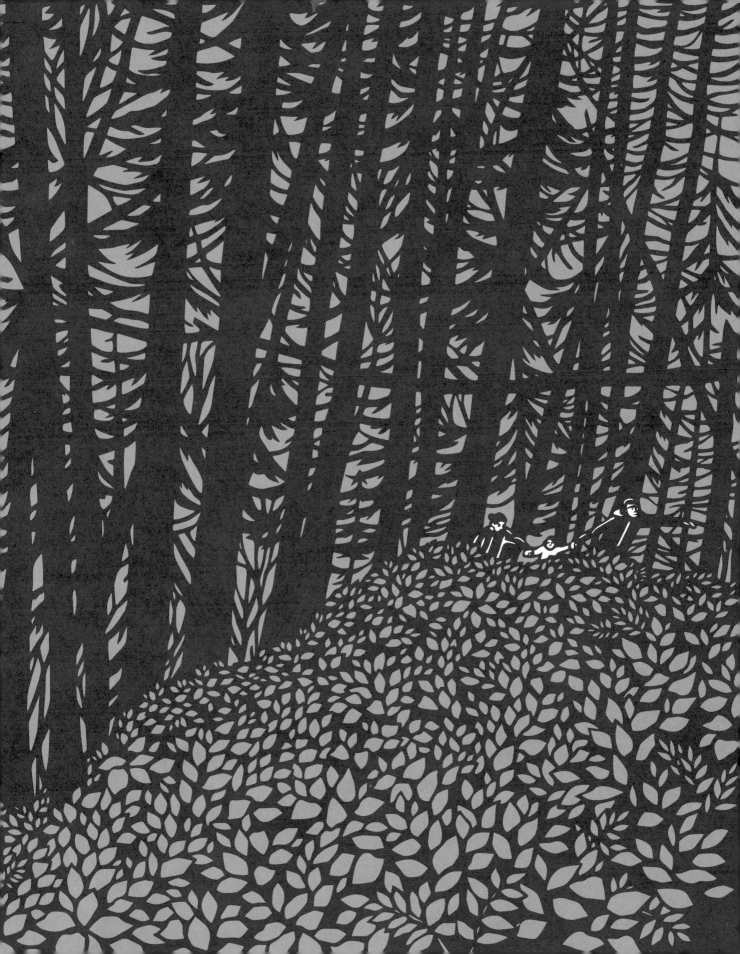

SHARE

Finn holds on to Eric's shoulders as they sled down the steepest hill in Olympia. To see my child race down an icy hill and become a tiny speck of speed is terrifying, accepting, and altering. When the snow melts and the eclectic party is over, there is debris of all kinds at the base of the hill, and there are bold kids with wild eyes.

CONVENE

I had one thing right: all gatherings in 2020 were outside and small. The annual tree hunt was canceled though. We usually drive up logging roads until our city cars cannot safely go farther. We make a fire next to the road and eat tamales. In 2019, it rained continuously. We wore extra hats and the fire smoked more than usual. The tamales were the best ever.

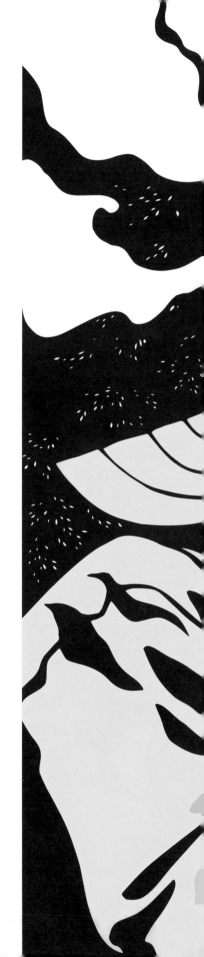

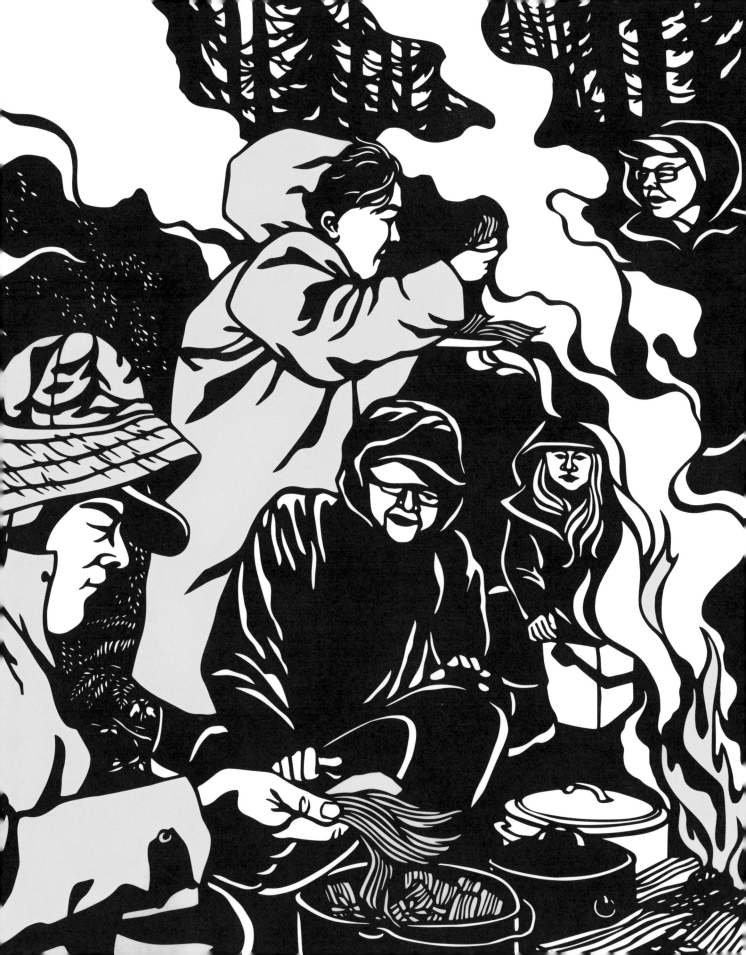

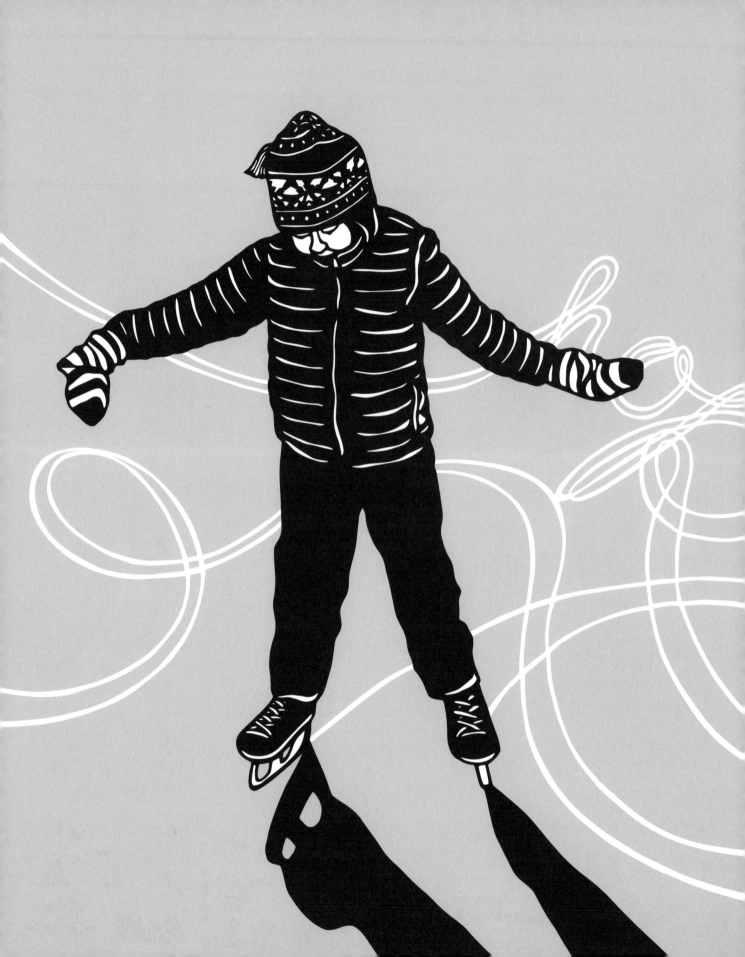

HOPE

One year the pond froze, and there were roses of ice blooming from deep below. We found a pair of skates that were too big and a bit mouse-chewed. And with socks as mittens, Finn headed out onto this new world.

I made my first calendar in 1998. Twenty-four calendars later, there are many people who accompanied me along the way, encouraging, supporting, and inspiring this work. During these past seven years of creating, Jay T. and Finn walked with me and ate breakfast with me and adventured with me. They are the first to bounce ideas off of, guide challenges, and celebrate discoveries. Pat Castaldo and Scott Ogilvie spent hours and weekends on the computer preparing images for printing while I kept cutting more. Aaron Tuller and Pat C. and the workers at Buyolympia coordinated shipping worldwide while I picked berries. My mother and I had an ongoing conversation while I worked. The next collection of my work will be made without her voice and weather updates. Amber, Lois, and Eric read text as well as inspired many images. Tina and Sophie participated in May Days and adventures. Saima came over for naps and encouraged critical discourse at the dinner table. Michael Jacobs and the editors at Abrams Books helped me create many books all these years, and I especially thank him (and them) for this book. Meredith Clark and Michael Sand edited this collection of my work. I also thank all the people who have collected my work and supported me, be it an original papercut or a calendar on the wall of their kitchen. Margery and Jocelyn left this Here for me. It is the land and water and home of the Squaxin and Nisqually Tribes since time immemorial, and home of many cedar trees, birds, snakes, and bumblebees. I thank them for their contributions to this place along the shore of the Salish Sea.

Additional thanks, in random order, to Nicholas Bell, Steve Herman, Lanny and Linda, Browsers Books, Lincoln, Nova, and Avanti teachers; Sarah Hanavan, Erik Brown, Tom and Wyndham, Bret and Denise, Jonn and Lisa, Miriam and Lena, Susan Rosen, Julie and Michael, Ian MacKaye, *Orion* magazine, Hatcher and family, Calvin Johnson, K Records, Tae Won You, Lisa Scott Owen and Tony Alva, Frank and Casey at Danger Room Comics, Helsing Junction, Little Big Farm, Common Ground, Northwest Maritime Center, Mystic Seaport Museum, Stella, Al, and Cypress; Erica, Greg, Bella, and Thea; Canada's maritime parks, Ira Coyne, Greg and Matthew, my sisters and family and in-laws, Susan Van Metre, Steven Malk, Abrams Books for Young Readers, Cameron & Company, Balzer & Bray, Carson and Colin, KBK Crew, Mecca Normal, Yo La Tengo, The Decemberists, *Clearwater, Nevermore, Scamp, Ichi, Imp*, Rainy Day Records, assorted Davids, Melanie Falick, *Small Craft Advisor*, Kris and Steve, Don Freas, Chris Boe, Dan and Theresa, Pete, Mary, Willa, and Anabell; Alex, Anne, and Marilyn; Yayoi, Norio, Minomusi, Mazza Museum, Trinacria, Donna Watson, Sitka, Anacortes, Orcas Island, Kellie and Jen, Phil Elverum, Agathe, Geneveieve, Charles Mudede, Sasquatch Books, Orca Book Publishers, and Olympia, my home. This collective holding makes my work possible. Thank you!